# MUHAMMAD ALI

## A Thirty-Year Journey

Introductions by Muhammad and Lonnie Ali, Bill and Camille Cosby,
Jim Murray, Gordon Parks, George Plimpton, Alvin F. Poussaint, M.D.,
Budd Schulberg, Ralph Wiley, and A. S. "Doc" Young

## Howard L. Bingham

Simon & Schuster

New York London Toronto Sydney Tokyo Singapore

**SIMON & SCHUSTER**
Simon & Schuster Building
Rockefeller Center
1230 Avenue of the Americas
New York, New York 10020

Copyright © 1993 by Howard L. Bingham

Designed by Deirdre C. Amthor

Printed and bound in Italy

1   3   5   7   9   10   8   6   4   2

Library of Congress Cataloging-in-Publication Data
Bingham, Howard L.
Muhammad Ali : a thirty-year journey / Howard L.
Bingham ; introductions by Muhammad and
Lonnie Ali . . . [et al.].
p.   cm.
1. Ali, Muhammad, 1942–  —Pictorial works.   2. Boxers
(Sports)—United States—Biography.   I. Title.
GV1132.A44B56   1993
796.8′3′092—dc20
[B]                                                      93-7901
CIP
ISBN: 0-671-76078-5

*To my dad, the late Willie E. Bingham, and my mother, Willie E. Bingham, who taught me how to treat all people with kindness and respect; and to my sons, Damon and Dustin, who I hope have learned the same from me.*

# Acknowledgments

I want to thank Muhammad and Lonnie Ali, Bill and Camille Cosby, Jim Murray, Gordon Parks, George Plimpton, Al Poussaint, Budd Schulberg, Ralph Wiley, and Doc Young for their kind words in the introductions to this book.

I also want to thank Harold Lipton and Ron Dinicola, my attorneys, for keeping me out of trouble; Paul Adaji, my friend, for giving me shelter and a home away from home while I'm in New York; George Washington (a/k/a Abraham Lincoln) for making all those trips from chilly New York to sunny Los Angeles to help me edit, even though he would rather have spent the time outside in the sun; Bunny Soria, my sister, who helped me get all my photographs, going back to 1962, out of boxes, filed, and organized; Damon and Dustin, my sons, for helping with the filing, running errands, and dropping me off and picking me up from the airport; Fred Hicks, my friend for many years—I miss you and wish I had listened to you when you told me to put dates on everything, because then I might have gotten this done on time; Peter McGill, for showing me how to look at pictures and for helping me appreciate my own photos; Bernie Yuman, my friend, who keeps me going; my friends at Studio Photo and Elite Photo for proofing my negatives, and everyone at Silver Lab for all your help printing; Jeff Neuman, for understanding me and working with me; and Stuart Gottesman, for all the time and effort that finally made this book come together. Stuart, I mean Scott, like the song says, when your phone don't ring you'll know it's me.

Special thanks to Gordon Parks, my mentor, whom I met in L.A. in 1963 while he was taking pictures of Malcolm X. I'll never forget the time a few months later when I walked by a doorway in the Time & Life Building and you called out, "Howard Bingham." I felt so proud that you remembered me. Also, thank you for taking the back cover photo of me and Ali. It means a lot.

# Muhammad and Lonnie Ali

Perhaps once in a lifetime you meet a person who is so special that you think yourself blessed to have that person as a friend. I met Howard Bingham when I had just started my professional career in boxing. We met by chance in Los Angeles in 1962, and we've been together ever since.

I wasn't heavyweight champ yet, and the only thing I had a lot of was raw talent and ego. I wasn't rich and famous, and I traveled by bus or train instead of by Rolls-Royce and plane. But Howard befriended me.

This book has been a long time coming—thirty years in fact. It brings back a lot of good memories and journeys I had forgotten. I hope you enjoy this book as much as Howard and I have had living it.

Howard, thanks for the memories and the good times we've had. I hope there are many, many more to come.

Love.

—Muhammad Ali

One bright California afternoon, Muhammad and his brother were standing on the corner of Fifth and Broadway in Los Angeles taking in the sights. Both were small-town boys, making their first visit to the big city. Muhammad (he was Cassius Clay then) had made the trip to announce his upcoming fight with George Logan at the Los Angeles Sports Arena. While looking at a slow-passing car, he heard a voice asking him, "Need a ride?" Muhammad quickly answered, "No, that's okay. We're just watchin' the sights." "Well, would you guys want to take a ride with me? I'll show you around," the young man eagerly asked. Muhammad has never met a stranger he doesn't want to know, and he and his brother got in the young man's car.

That young man was Howard Bingham, a photographer from a local black newspaper who had attended Muhammad's press conference earlier in the day. The two became fast friends. Four wives, nine children, and thirty-one years later, Howard remains as close to Ali as ever.

It would be difficult for me to chronicle Muhammad and Howard's long and lasting relationship. I met Howard shortly after I met Muhammad. I must have been seven or eight. He came with Muhammad to Louisville to visit Muhammad's mother. After that, I did not see him much until I moved to Los Angeles in 1984. It was then I realized the friend Howard was to Muhammad. He has been Muhammad's close friend for a long time, but over the last ten years he has become "our" best friend.

For the past thirty-one years, Howard and Muhammad have shared much: The victories and defeats in the ring. Muhammad's three-year exile from boxing. His conversion to the religion of Islam and the changing of his slave name (Cassius Marcellus Clay) to his chosen name of Muhammad Ali. His marriage to four different wives and his three divorces. The birth of eight children and the adoption of one. His

retirement from the ring, then his decision to fight again, and subsequent second retirement. And more recently, his battle with Parkinson's Syndrome and the loss of his father. They have traveled countless miles together, visited numerous countries, and met many of the movers and shakers who have influenced and shaped the world as we know it today.

Howard has observed and captured some of the most memorable of these moments with his camera. It is said a picture is worth a thousand words. If so, this collection of photos will be worth more. Because of his intimate standing in the immediate Ali family, Howard was allowed to take pictures of Muhammad and his family without permission or restrictions. In light of this, he is most likely the only man on earth who has a complete photo history of Muhammad. The photos published in this book represent only a fraction of his collection.

With the passing of each year, it is only too obvious Muhammad is happy he gave Howard free rein with his camera. Now, many times when they are together, Howard will bring a stack of 8 × 10 black-and-white glossies for Muhammad to look through and select photos for his own personal keepsakes. During these sessions Muhammad and Howard sink into large overstuffed chairs and laugh and talk about different people in the photos, or the events that surrounded them at the time the photos were taken. Each photo brings back cherished memories for both and silently reinforces the bond that exists between them. It is on these particular occasions you get a glimpse of the Muhammad and Howard of old and realize what good times they must have shared. What an adventure!

A strong contributor to the lasting friendship Muhammad and Howard share is their mutual sense of humor. Both are quick to laugh and play practical jokes on any unsuspecting victim. No one seems to be exempt—not even one from the other. At one time Howard owned a giant schnauzer named Rocky that he kept fenced behind his house in Los Angeles. Whenever we visited, Muhammad, being the tease that he is, would always—and I mean *always*—approach the fence and tease Rocky by making growling sounds until the dog foamed at the mouth and started barking in a frenzy. Satisfied he had gotten the best of the dog, Muhammad would turn away and go into the house. Howard witnessed this on many occasions and often warned Muhammad that

one day Rocky might get loose and attack him. Muhammad would simply scoff at the idea.

One day Muhammad teased Rocky quite a bit and Howard issued his usual warning. Muhammad ignored Howard's remark and turned to walk into the house. Howard, however, let Rocky out—on his leash—and called to Muhammad. Muhammad turned just in time to see Howard with this large dog coming toward him. In a flash, Muhammad yelled and ran down the street like an Olympic runner. I wish we could have clocked his time. Howard doubled over in laughter and Muhammad just kept running until he got to the corner and looked back to see if Rocky was in pursuit. When he realized he was safe, he, too, doubled over in laughter. Needless to say, Muhammad never bothered Rocky again.

Laughter and jokes aside, Howard endeared himself to Muhammad over the years with his unwavering loyalty and his genuine concern for Muhammad and his family. Regardless of Muhammad's standing in the nation's public opinion poll of who's hot and who's not, Howard has been there for Muhammad. He always has been and he always will be Muhammad's friend in spite of whatever or whomever. Howard loved Muhammad for the person he was and is, not the legend he has become. He decided to climb the mountain behind Muhammad, and he has made the long journey down at his side with an outstretched hand for support and encouragement whenever needed.

When he was still in the ring, Muhammad had an attorney who frequently made the comment, "Everybody needs a Bingham." He was right and we should all be so lucky to have him as our friend.

For me, writing about Howard is very difficult because so much of what I feel is in my heart. Nothing I could ever write would fully convey what he has meant to me over the past ten years, since I moved to Los Angeles to be with Muhammad. His friendship never faltered when I was in need of support. He has been my brother, counselor, cohort, assistant, and gatekeeper. Although he and I have not been friends as long as he and Muhammad, he is just as dear to me as he is to Muhammad.

Life without Howard would be hard for me to imagine. Who else would call me at 6:00 A.M. for no particular reason and expect me to be

conscious. Or call me without warning on a six-way (six people on a conference call)—a technological feat AT&T has not even figured out —with only a three-way calling system. Or take my first-class airline ticket and get three roundtrip red-eye economy-class tickets from Los Angeles to Chicago and then tell me "you get what you pay for" after I call him and complain no food was available on the flight and there was a charge if you wanted a soda. Or take Polaroids of me when I am rag tired and asleep on a plane back to the States after a ten-day tour of Indonesia, and then pass them out to the desk clerks at the hotel upon my arrival. Or hang up on me without notice when a particular wife of another well-known celebrity calls. Or tell me, at the end of a very hectic and trying day with Muhammad's schedule, "I was here before you came and I'll be here when you are gone."

Well, for Howard L. Bingham, that is par for the course. He was here before me and I hope he will be here when I am gone, and I don't think Muhammad or I would have it any other way.

—Lonnie Ali

# Bill and Camille Cosby

Howard Bingham possesses and is possessed by a unique love of photography. And that love is inseparable from his friendship with Muhammad Ali. Their friendship began early in the 1960s and continues to grow because of the mutual respect the two men share.

Howard has taken countless photos of Ali in his most public and private moments. And, quite obviously, there are many celebrities in these photos—who, by the way, would just as soon have Howard crop their haircuts (that being the day of the Afro). I'm proud to be one of them.

If the day ever comes that my photo album is published as a book, it will be comforting to know Howard Bingham has taken so many of the pictures that matter most to my family and me.

—Bill Cosby

I have known Howard Bingham for most of my adult life. It's difficult to remember exactly when I met Howard; I just know he has been a friend for a very long time. Many people who know Howard have the same warm feelings for him that I do. That's because he's so gregarious and friendly.

Although our exact meeting isn't memorable, an early incident with our dogs is distinct in my mind. In the 1960s, Howard and I both owned German shepherds; Howard's was female, mine was male. We decided to introduce our thoroughbred dogs to ascertain if they would like each other. Howard brought his dog to my home and we allowed the dogs to have a few moments of privacy in the yard while Howard and I retreated indoors. However, when we stopped to observe the dogs through the window, we were astonished! By this time, our dogs were mating!

So there we were, Howard and I, staring at our dogs, who were obviously no longer strangers. Suddenly and uncontrollably, we began to laugh—not soft laughter, but roll-in-the-aisle laughter, the kind of shared laughter that cements a friendship.

In 1969, when Bill starred in a television program, "The Bill Cosby Show," he asked Howard to be the still photographer for the show. However, membership in the motion picture and television photographers' union was restricted to white males. Nonetheless, Bill asked Howard to be present daily on his program's set. It was a union rule that a photographer was eligible for union membership if he worked on a set with a union photographer for thirty days. Of course, previously, African-American photographers were never asked to work on any sets. So every day for thirty days, while a union photographer just sat in his

chair, Howard took photographs of the cast of "The Bill Cosby Show." The show had to pay both the union photographer and Howard.

After thirty days, Howard was admitted into the union, but at its lowest rank, Group Three. Since union rules mandated the hiring of a Group One or Two photographer ahead of any Group Three, Bill continued to pay both Howard and a Group One photographer for the duration of the show.

Throughout the twenty-plus years that Bill and I have known Howard, we've shared a relationship with him based on honesty, trust, and professionalism. Because of this special bond, Bill and I have asked Howard to be our photographer for a wide array of projects, including photographs for print advertising, television shows, movies, books, record albums, videos, and magazine features. And whenever Bill and I want a photograph taken for personal reasons, we want Howard behind the camera.

Even though Howard's work has appeared in major magazines, he's never released photographs without permission or abused our friendship in any way. Moreover, Howard has been my mentor; ten years ago, he taught me how to use the camera. With Howard's help, I've evolved into a highly skilled amateur photographer. His love of photography shows through in the way he joyfully instructs his students.

In my experience, most successful people tend to be competitive. Howard is no exception; his competitiveness became apparent during a toboggan contest we held at our home several Christmases ago. After watching Howard defeat ten people (including myself), I never again doubted his perseverance, determination, and tenacity. Especially because winning ten races meant climbing the hill ten times. Now that's impressive. That is the vital spirit that has made Howard a very remarkable photographer.

—Camille Cosby

# Jim Murray

You always knew Ali was going to be all right as long as Howard Bingham was there. Ali trusted him. *We* trusted him. The hard-faced men came and went, the sycophants, con men with their own agendas, the manipulators, money-grubbers, users. Howard remained. He was the soft center in the Ali entourage.

Even Ali's Muslim caretakers recognized Howard's unique position. It was friend. Like all successful men—in fact, like *all* men—Ali didn't have enough of those.

Ali didn't take advice from too many people. He took it from Howard. Officially, Howard was Ali's photographer. He was more than that. He was often Ali's conscience.

He had to know Ali as it was given to few men to know him. But he never betrayed a confidence. He was best man at Ali's wedding. He went on the honeymoon. The tabloids would have made him a rich man. Howard would have been horrified at the thought.

It is a matter of record that other members of the Ali camp—say, Drew "Bundini" Brown—used their relationship to the champ to improve themselves socially, especially with the ladies. Howard didn't bother to. I have seen him at functions virtually ignored, until I let slip that he is probably Muhammad Ali's oldest friend—then the attitudes toward him changed dramatically. Bingham is just amused.

He had more than a ringside seat, he had an insider's seat, at one of the great sport stories of the century. He was with Ali at the zenith and the nadir. When Ali fell tragically ill, others took down the balloons, put away the flags, muffled the shouts, and took off for newer sensations. Howard Bingham is still there. He always will be.

The world is used to the bombast of "I am the greatest!," the denigration of foes, the public persona of Ali, the champ in the mold of "I can lick any man in the house!" Bingham knows the inner man. Bingham was there the night he won. Bingham was there the night he lost.

Ali is a twentieth-century sporting hero whose like we shall not soon see again, if ever. Fair of face, fleet of foot, glib of tongue, he commanded adulation. He met with kings, prime ministers, dictators, presidents. He is one of the few men ever to get the Supreme Court of the United States to unanimously agree on anything.

If you look closely at any picture of these great events, you will see in the background (always in the background) this pleasant, smiling, unassuming, eager-looking man with a bemused expression on his face.

That will be Howard Bingham, a friend any man would be lucky to have. When Ali is on his deathbed, chances are he will rise up on one elbow, look around, and demand, "Where's Howard?"

Howard will be right there.

---

# Gordon Parks

In those loose, rambling hours between hostilities, Muhammad Ali was constantly in search of someone he could open his soul to. Crowds were welcome. He loved crowds, but even more he loved to plant himself dead center in a bunch of school kids, sound off, then warm to their glee and adoration. Yet there were also times when despair crept in and refused to leave him, when suddenly there was just loneliness. During those rare moments he had a need to attach himself to someone he felt close to, someone who would leave him with his silence. No one in his entourage was more suitable for that than Howard Bingham. Even before Ali destroyed Sonny Liston, Howard had begun moving easily with him through the silk bazaars and markets of misery—then later through the loves, the marriages, and the divorces. He never asked indiscreet questions or allowed his camera to become annoyingly intrusive. This summoned restraint, since Ali's every move invited intrusion.

The loyalty remained as time shaped their unrivaled friendship—one that never faltered even when Ali was being eaten up by distress.

There is, and always will be, a strong spiritual bond between the two men. Howard suffered the blows Ali took more than Ali did. Today he suffers equally when Ali ignores the medication his doctors prescribe for him. "Ali's stubborn, hardheaded—but full of love for everybody," he laments. Having known Howard Bingham during my years as a photographer at *Life* magazine, I have good reason for understanding Ali's appreciation for their comradeship. I have deep respect for Howard as an artist and a staunch friend.

Howard's words and photographs recall so many things about Muhammad Ali—things of different sizes falling restlessly upon my memory. Only a rare few have as many selves as Muhammad Ali. To know and really understand him one has to sink deep into the geography of his soul. Howard has done that while observing him with the sensitivity of a blind man. The dedication page of Ali's memoir by Thomas Hauser holds these words: "For Howard Bingham, there's no one like him." From Howard's lips came these words: "I couldn't wish for a better friend than Ali." Bunched together, these acknowledgments seem unbreakable—as hard as stone. Ali and Howard love one another. It is safe to say that, regardless of what lies beyond them, that will never change.

# George Plimpton

Howard Bingham and I spent a morning together the other day. He was in New York with Muhammad Ali, who was in town to present and promote an "Ali" line of clothes at Macy's. I had thought vaguely

of dropping in on the event, but I wasn't especially looking forward to it. Though I covered many of his fights for *Sports Illustrated*, I hadn't seen him for a long time. Nor have I been much of a fight fan since, far too late, he retired from the ring in 1981. Since then, every time I've seen him on television, usually sitting silently at ringside, I am reminded that Oscar Wilde truly had it wrong; you don't kill the thing you love (which is what he said), what you love kills you.

So when Howard called, I asked him to come around to the house; we'd talk about the old times. He arrived with some of the pictures in this collection. We spread them out on the pool table. Every time Bundini Brown's wide, expressive face turned up, I'd laugh. When he was in exile from the Ali camp for refusing to convert to Islam, he worked as a part-time rug salesman—seducing me into buying a wall-to-wall orange carpet of such a resonant color that it seemed to cast the entire room and its occupants in an eerie glow.

After we finished looking at the pictures, Howard said, "Hey, you ought to come down and see the champ. He'd like to see you."

I shook my head. "He wouldn't remember," I said. "It's been too long a time. He's forgotten."

"Oh no. He'll remember. He called you 'Kennedy' 'cause he thought you looked like one."

I laughed and said that sometimes he called me "the author." He'd say, "Put the author in the front seat," and we'd drive off somewhere.

At the last moment that day I changed my mind and dropped in at Macy's . . . just for a glimpse. When I got there, the fashion show was over and Ali was leaving, which on such occasions is a lengthy process since he moves through the crowds signing autographs, passing out his picture and tracts promoting Islam. It's a wonder he ever gets out at all.

I stood at the outer edge of a ring of people, perhaps twenty deep, Ali in the middle, slowly working his way toward the exit. On the far side of the crowd I spotted Howard, cameras dangling from his neck. He grinned and waved.

Just then Ali spotted me and began pushing through the crowd. At first, I thought he was heading for someone else, but then a few feet away he put out his arms and pulled me to him. He whispered in my ear, "Hey, hey, Kennedy." I was enormously touched; indeed, I am not

ashamed to say my eyes filled with tears.

So, that's that. I suspect Howard told him I might be coming, so he'd be prepared. Maybe not. But if he did, it was something a true friend would do. Muhammad Ali has been lucky through the years with the friendship of this fine man. So have I.

---

# Alvin F. Poussaint, M.D.

These magnificent photographs by Howard Bingham salute the life of Muhammad Ali, a man who rose from humble beginnings to emerge as one of the great historical figures of our time. It is enough that Muhammad Ali was an outstanding heavyweight champion, but he will always be remembered as more than an athlete. Ali, a man without peer, has struggled with the issues of racial and social indignities in a country steeped in the legacies of slavery and the oppression of African Americans.

Cassius Marcellus Clay, Jr., was born January 17, 1942, just over a year after the United States became militarily involved in World War II. For the second time in this century, the United States was fighting a war to make the world safe for democracy while its own army remained segregated. It was this nation, poised for upheaval and change, that he traversed, not only as a boxer but as an African American in search of equality.

Muhammad Ali was not only a critically important symbol to black Americans during the civil rights era, he also taught whites much about the hurtfulness of racism and the courage of black people to stand tall in a discriminatory society.

His racial consciousness came of age when, at twenty-two, he gave

up his slave name, Cassius Clay, and became Muhammad Ali, a loyal member of the Nation of Islam led by Elijah Muhammad. This was before the black power movement in America, and it was considered a radical step even by black civil rights leaders. There is no doubt that Muhammad Ali's action, as a powerful and successful black man, encouraged other black Americans to become less accommodating to white racism. He withstood widespread criticism, including the early refusal of the press to call him by his chosen name, but he prevailed, and that gave tangible support to the development of the black consciousness movement in the late 1960s.

The crowning moment in Muhammad Ali's political life came in April 1967, when he refused to be inducted into the armed services to fight in the Vietnam War. He was stripped of all of his world heavyweight titles and not allowed to box, and risked a punishment of up to five years' imprisonment. As the case passed through appeals courts, Ali, because of his principled stand, gave up millions of dollars of potential income. He was in virtual exile for almost four years. Finally, in June 1971, the U.S. Supreme Court overturned his conviction and all criminal charges were dropped.

Muhammad Ali, out of shape, weakened by his inactivity and four years older, set out on the difficult journey to regain the heavyweight championship. That he had both the physical stamina and psychological resolve to do this is in itself remarkable. But part of Ali's greatness is that he persisted and persevered because he truly believed in himself and his power to overcome. He was a model for athletes to give their maximum effort to succeed. That effort continues today; no longer the robust athlete, he has been diagnosed as having a neurological condition similar to Parkinson's disease, possibly caused by poundings sustained in the ring. Nonetheless, Ali, with his typical persistence, continues to live an active life and has become even more beloved by his millions of fans. Ali remains a role model to thousands of young people around the world, particularly African-American youth.

Muhammad Ali's face is one of the best known all over the world and he remains an ambassador of peace and goodwill. With this wonderful photographic work of Howard Bingham's, his face will be recognized even more widely and for many generations to come.

# Budd Schulberg

Memories of Muhammad Ali are so vivid, so varied, so compelling that in a short piece on his long and unique career one is faced with an embarrassment of riches. There is the young, brash, outrageous, frisky colt of twenty-one, whom I met for the first time in a Las Vegas hotel on the eve of champion Sonny Liston's second fight with Floyd Patterson. We met through David Brinkley, who was interviewing the "kid" for his "Brinkley Journal," produced by my late brother Stuart. Boxing was not Brinkley's favorite sport, but he found the Cassius Clay persona irresistible. The high-rated Huntley/Brinkley newscast had a then famous sign-off: "Good night, Chet." "Good night, David."

"David, let's do the sign-off," Cassius said. "Good night, David . . ." And when Brinkley went along, "Good night, Cassius," the undefeated pretender to Liston's throne literally laughed so hard he rolled off the bed. "David, let's do that again," Cassius begged. They did, half a dozen times, each time with the same infectious laughter from this wunderkind who seemed to be ready to eat the world for breakfast.

Cassius had been everybody's favorite athlete at the 1960 Olympics in Rome where he won a gold medal. None of us who followed this demanding sport had ever seen a man that big move that fast. He was Nureyev in boxing trunks. But he had had less than twenty fights, and although he had stopped ancient Archie Moore and busted up the stoic British bleeder Henry Cooper, he was still untested. But also undaunted. He, and practically he alone, was convinced he could take the title from Sonny Liston, who destroyed ex-champion Floyd Patterson in a single humiliating round, a replay of the two-minute devastation the year before.

I still remember the inner tremble I felt as young Cassius and his

hyper alter ego, Budini Brown, turned the weigh-in for the historic fight in Miami into a one-hour freak show in which they banged angry canes on the floor and chanted "Float like a butterfly, sting like a bee!"; screamed, ranted, and lunged at the grimly self-controlled Sonny until boxing writers like Jimmy Cannon, Al Buck, and Jesse Abramson seriously suggested that the fight should be canceled because Cassius was obviously suffering from fear-induced hysteria. His blood pressure had gone through the roof. The odds on the fight were ten-to-one Liston, but knowledgeable boxing buffs were saying the odds should be ten-to-one that the terrified Cassius would even show up.

But Cassius Clay was not only the fastest heavyweight in the history of the division, he was also the most imaginative, consciously manipulating opponents through psychological strategies that matched his speed of hand and foot. One hour after the weigh-in hysterics, Ali's doctor and cornerman, Ferdie Pacheco, told me the unbelievable: Cassius's blood pressure was back to normal. Dr. Pacheco was convinced that the hour-long hysteria was simply a self-induced psychological ploy to "flap" the seemingly unflappable champion. "Cassius is completely in control of himself," Ferdie reported. "He knows exactly what he's doing. It's going to be a very interesting evening."

For once, Dr. P. was indulging in understatement. Cassius used his wicked jab and ballerina footwork to keep the dangerous "ugly bear" at bay and opened a nasty wound in the surly champion's cheek. The bell for round seven found the ten-to-one favorite slouched on his stool, claiming a shoulder injury, and refusing to come out to eat more of those flicking jabs from this upstart twenty-two-year-old who had suddenly revolutionized heavyweight boxing.

The next morning, at the press conference, we were confronted by quite a different Cassius Marcellus Clay. The screaming, shouting dervish of the day before had been replaced by a somber, serious champion who now spoke so quietly that reporters in the back of the room were shouting "Louder." He was abandoning his "slave name," Clay, he announced, and should now be addressed as "Cassius X," a first step in his journey to becoming Muhammad Ali.

I had an opportunity to talk to him for a few minutes alone, and asked him what his immediate plans were. His answer: "I plan to visit

all the capitals of the world and to talk to all the wise men on this earth. After all, I am the champion of the whole world."

His comment that morning may have sounded a little wild and crazy, not to say pompous and self-inflated. But the wonder of it all is that this young original not only had the power to reinvent himself but to make his legend a social force. What seemed a vain boast soon became a reality. Indeed, as this is written, in late February 1993, almost thirty years after Muhammad's portentous announcement, he is off to Beijing, China. Three decades after becoming champion of the world, he is still the only human being on planet Earth sure to draw a crowd in every city on all five continents.

As memory flashes of Ali keep crowding in, let me tick off a few of the unforgettables:

I'm in the limo with Ali, trainer Angelo Dundee, and members of the entourage on the way to the weigh-in for Ali's 1971 classic with Joe Frazier. Ali speaks like a meek little boy: "Angelo, I'm not only bigger than Jimmy Ellis [interim champ after Ali was illegally deprived of his title], I'm faster, right?" Angelo: "Sure, champ, Jimmy's fast but you're even faster." Ali: "And I punch harder?" Angelo: "Absolutely, champ. Much harder." Ali: "So if Jimmy held his own pretty good until he got tagged, I should be able to do better than Jimmy, right?" Angelo: "No doubt about it, champ. You're gonna win it." Ali falls silent, until we reach the Garden. The limo door opens. The fans swarm in. Ali hurls himself out of the car and shouts to the crowd: "I am the greatest!" I watch in fascination as the goes through a personality transformation almost as extreme as at the Liston weigh-in. All the silent, lonely, personal doubts are gone, and he is the Public Ali now, living up to his legend, and embellishing it at every golden opportunity.

The next morning he is in bed at his hotel, after losing to Smokin' Joe Frazier in one of the most stirring heavyweight championship fights I have ever seen. It is his first loss in an illustrious career that goes back a dozen years. His head is still swollen grotesquely. He is still semi-exhausted from the superhuman effort that has sent the winning Frazier to the hospital.

Everyone had predicted that Ali's grandiose ego would not permit him to lose without pushing him to the brink of suicide. "They better

have a net outside the hotel," a "friend" had quipped. But there, in bed, was still another Ali, the quiet philosopher, still acutely conscious of his responsibility as a role model.

"In every fight someone has to win and someone has to lose," he said. "Like my people, we have our victories and we have our disappointments. I have to show my people we know how to lose, and still come back again."

And sure enough, soon after, Ali is back on TV, charming millions with his strange alchemy of arrogance and humility. He's back on the campus circuit bringing thousands of white students and black students together cheering his catchy doggerel poetry and his independent, rebellious, and positive philosophy. In defeat, he's a Black Phoenix rising. The indomitable resilience that inspired my writing "Loser and Still Champion" after the Frazier defeat motivates the Muhammad Ali we know, revere, and love in the nineties—the man, the spirit, and not merely the ring genius, that his devoted friend Howie Bingham reflects so movingly in his insightful photographic biography.

# Ralph Wiley

Inside the ring of twentieth-century iconography, Muhammad Ali doesn't have to take a back seat to anybody. He was for a time the most famous person in the world, an insufficient distinction when taken alone. But Ali was also the most photogenic of the famous, the most accessible and natural. And who is Howard Bingham? Muhammad Ali's friend and his historian, as it turns out. Others from LeRoy Neiman to Malcolm X to the Honorable Elijah Muhammad to Howard Cosell to Don King to four comely wives captured Ali briefly, in their own fash-

ions and agendas. But unlike Bingham, they were unable to know all of him, or hold him still; they couldn't break Ali's appointments with his Times.

In the cold universe of Good and Bad and no in-between, Ali was not merely of Good, he was the *champion* of Good, its last line of defense, the keeper of its flickering flame. The other words woven in, around, and through this collection come from some of those talented people, themselves mythic or mythmakers, who knew Ali as yet another within their own constellation, a man they knew they could touch, hear belch, and catch drooling while he slept. They knew he was a man, just a human being who could be cruel or afraid or who could cry, a man who would grow old and halt one day, a man who'd often done that which he would one day regret.

I never knew Muhammad Ali in that way when I knew him first and best. For twenty years, in that too-brief epoch of idealism that exists between the ages of nine and twenty-nine, in the years between 1961 and 1981, I knew him as an infallible icon who won even when he lost. He was infallible in a sense of never giving up on himself, on the power of self, the essence of one—therefore never allowing me to do so either. I was an impressionable twelve years old when he wrested the world heavyweight boxing title from Charles "Sonny" Liston before exclaiming, "I'm pretty! I'm a bad man! I am the greatest of all times! I shook up the world! I shook up the world!" I was fifteen when Ali said, "I ain't got no quarrel with them Vietcong," and gave up the title of Heavyweight Champion of the World for such a curious reason as his own principles! I went into exile with him and ignored most other prizefighters. When he came back three years later, in 1971, I came back with him, older and different now, fighting on the strength of something besides mere youth.

Later, when I was aspiring to be a journalist and writer and man of at least some principles, I would write RALPH WILEY IS THE GREATEST SPORTSWRITER IN THE WORLD, BAR NONE over and over again on the IBM Selectric typewriters hanging ponderously over tables like Everlast heavy bags in my places of training. I pounded and pounded them, improving my speed, willing myself into a state of confidence my abilities did not warrant. After I had come close enough to this curious goal to stop worrying about it, I gave much inward credit to the youthful

Muhammad Ali; what had been a boast to him had been a kept promise to me.

Understand how much this was from a man whose recent ancestors had been illiterate sharecroppers, slaves, with no rights a white man was bound to respect; who whiled away time singing "Nobody Knows De Trouble I've Seen," or "Soon Ah Will Be Done With the Troubles of the World," before hearing the report of a pistol, or the crack of a neck, or a scream, cutting off whatever would have remained of so hopeful a lyric as Ali's shortest, perhaps truest bit of poetry: "Me. Whee!" I also know some of the people in these collected photos, like Malcolm X, and I know them as part of the essential myth, captured as such, here, now, by Bingham. And then who is Bingham? A quiet man who seemed to be everywhere Ali was; in the high court of Ali, Howard Bingham was one of many singers of songs—just a shooter, as they say in the trades, just a flexible, reliable, relentless shooter taking and giving impressions of this Ali mythology to which I am so indebted. But Bingham never stopped shooting.

Ali always seemed to know what was most eloquent about himself— first, the rapid-fire vocal delivery of his youth, his quick mother-and-country wit (which can be captured by a camera after all, it appears here, captured in those faces of those of us who heard him). Then Ali's eloquence came through his hands; he became obsessed with magic when he got older because he was accustomed to performing legerdemain in the ring. He had always amazed us and himself with what he could do with his bare hands.

Finally, Ali's eloquence came through his expressions, his face, his ways of facing us. He never seemed out of place, but he always seemed more in place when captured with children. He was more natural in a more loving setting than the boxing ring. Myth with the progeny of myth. And yet, miraculously, I don't feel you get the true feeling of the enormity of Ali as mythic figure until you see him alone, or see a photograph capturing him alone. It was when Ali stood alone that he captivated us without trying—when boxing, smiling, talking, thinking, joking, winning, defending himself, defending the collective self, making up the myth as he went along. He is best known for what he's done alone. One-on-one. And as we can see from the images you hold, even when Ali was alone, Howard Bingham was with him.

# A. S. "Doc" Young

His name is Howard Bingham. In my personal/professional ratings system, he is, first of all, a world-class nice guy; second, he is a great and famous photographer; and third, he is the most fanatical frequent-flyer I know. Bingham *loves* to fly, and he's constantly going someplace —England, China, or merely Philadelphia, Pennsylvania—touching down at home long enough to catch a nap, run a few errands, make and answer several telephone calls, and repack his suit and camera cases. Sometimes Bingham spends less than two hours at home between trips!

I've known Howard Bingham since the early 1960s. I have worked with him on many projects. I have seen him in many venues, and I have seen him grow professionally. At no time has he been less than what I say he is: the nicest man I know. A friend forever.

"I've been fortunate and lucky," Bingham told me one day at Dodger Stadium in 1969. "I have met people and I have been nice to people, and I try not to take advantage of them as other guys would. I have never been a real hungry photographer. There are guys around with triple my experience and they haven't received the breaks I've received. So I have to say that I have been very lucky, and I am grateful."

The oldest of seven children, five boys and two girls, Howard Bingham was born in Jackson, Mississippi, on May 29, 1939. When he was four years old, his family moved to the area south of Los Angeles, where he attended Centennial High School and Compton Junior College.

At Centennial, Bingham "took a course in photography, but didn't

learn that much." At Compton College, he majored in music but now admits, "My mind wasn't on school. I was heavily into having fun, hanging out in the student union."

Two of Bingham's neighbors—Gladys Allen and Lavern Hodson—were photographers. Bingham recalls, "They were always going here and there, doing banquets and things, eating free food, photographing pretty women, and I said: 'I like that. *That's* for me!'"

Bingham's first job as a photographer was with the Los Angeles *Sentinel*, the largest black-owned newspaper west of Chicago. At the start, he was more a flunky and errand boy than a photographer, and a month passed before Bingham was even placed on the *Sentinel's* payroll.

After six months at the *Sentinel*, Bingham was not only doing professional-quality work, he was also taking on outside assignments. That's what got him fired; the newspaper's business manager told him he couldn't work as an independent contractor and remain on staff.

"The firing hurt me really bad," Bingham says, "but that was the best thing that ever happened to me."

Soon two friends—Walter Williams, a wealthy recording company owner, and Jesse Robinson, a training executive in the Los Angeles postal system—gave Bingham a much-needed boost.

Bingham couldn't understand why successful people like Williams, Robinson, and the Hodsons took such a personal interest in his career. One day Bingham asked me, "Why do they like me?"

I was astonished by the question, but I told him the truth. I said they liked him because he was a very nice person. I told him he had a natural gift for making friends. I told him that he was a person who always gave good friendship in return.

At his lowest point, after he had been fired, Williams and Robinson inspired him.

"They told me, 'Don't worry about anything,'" Bingham recalls, "and I haven't since."

That was true in 1963.

That is true in 1993.

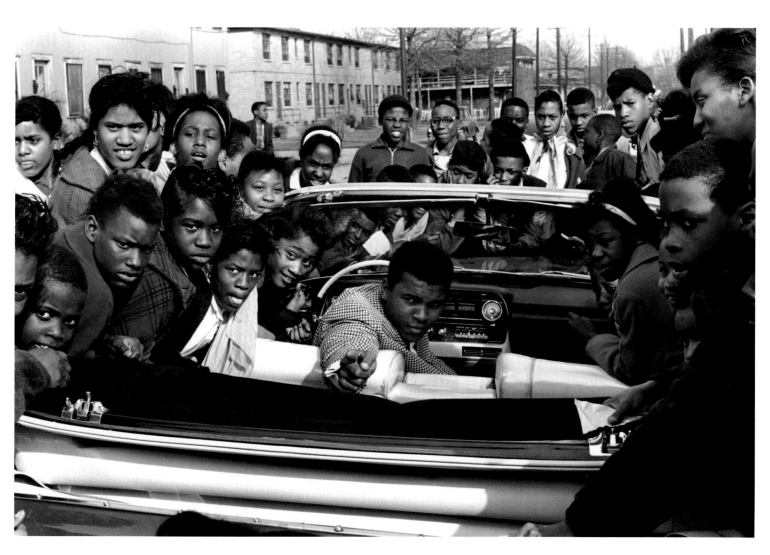

Louisville, 1963.

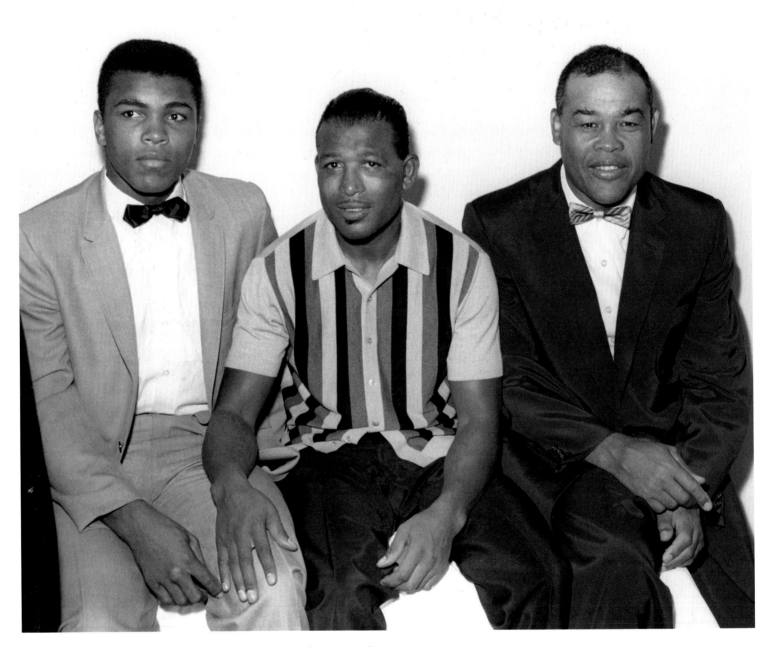

Los Angeles, 1962. With Sugar Ray Robinson and Joe Louis.

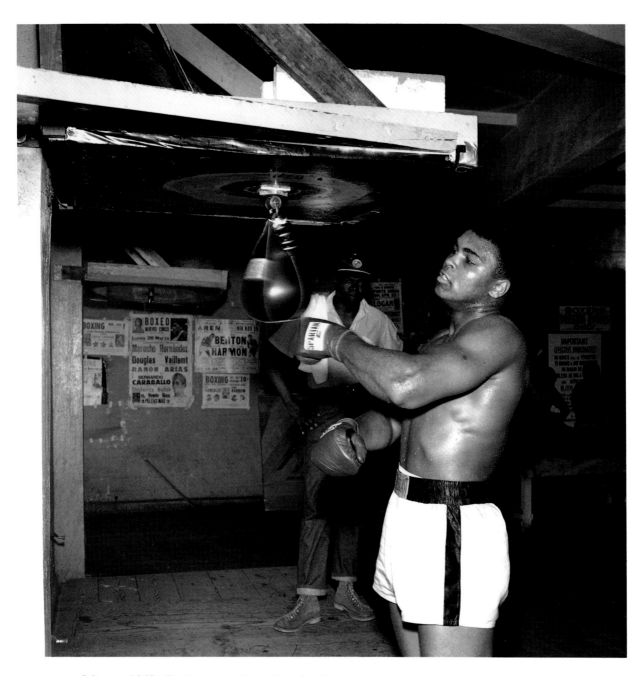

Miami, 1963. Training, as Drew Bundini Brown looks on.

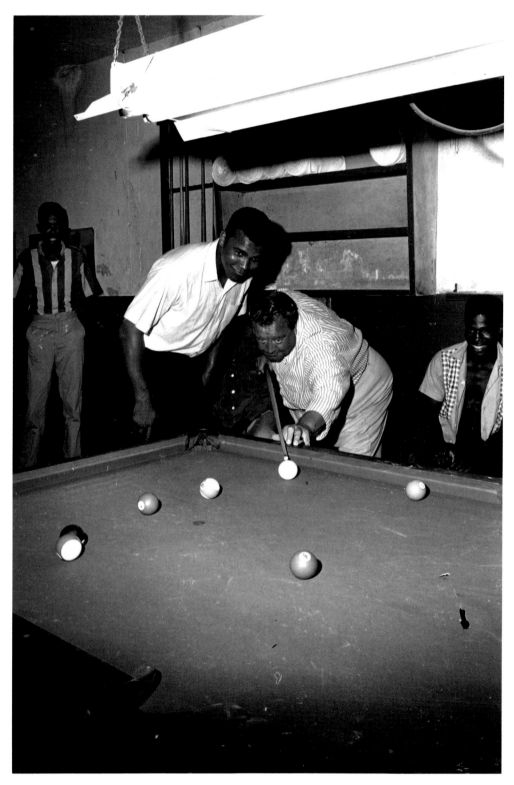

Miami, 1963. With Jackie Gleason.

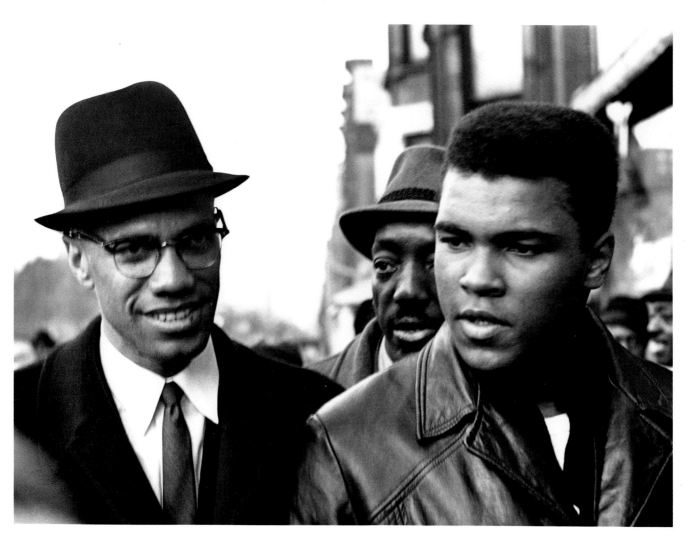

New York, 1963. With Malcolm X.

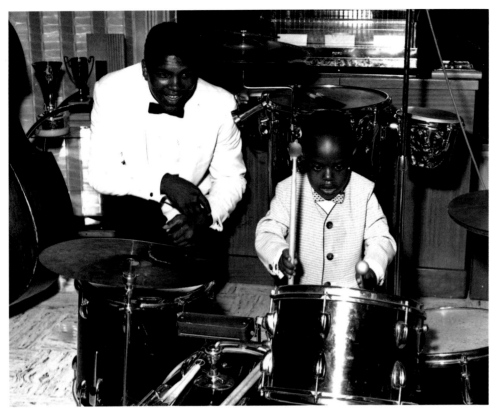

Los Angeles, 1962.

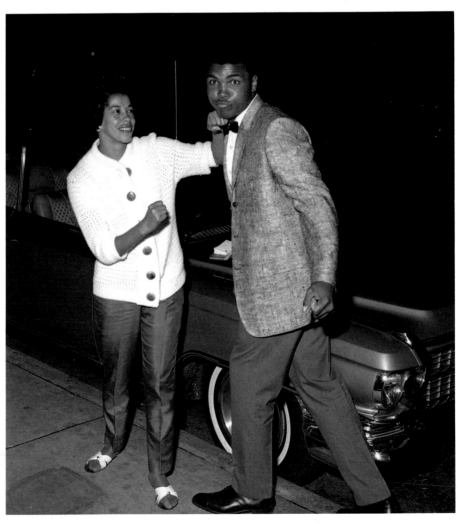

Miami, 1964.

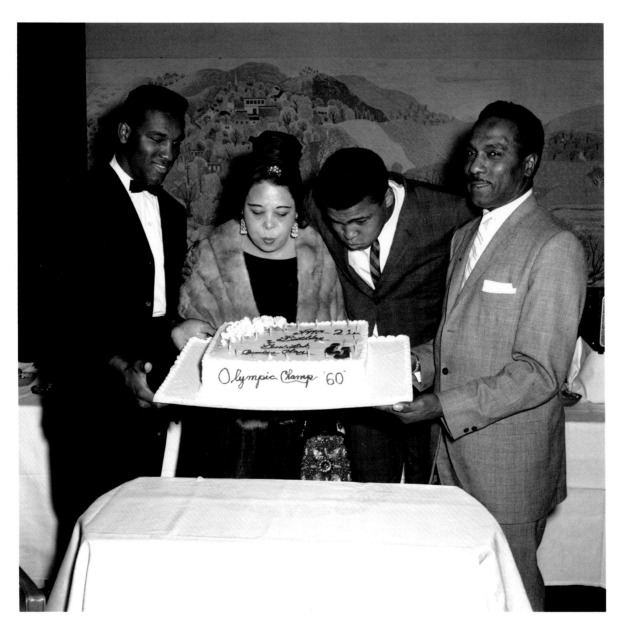

Pittsburgh, 1963. Celebrating his twenty-first birthday with his brother and parents.

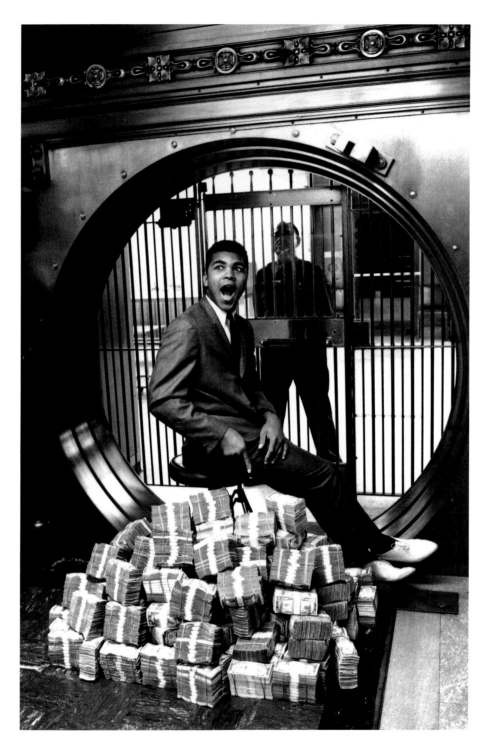

Los Angeles, 1963. Sitting on a million bucks.

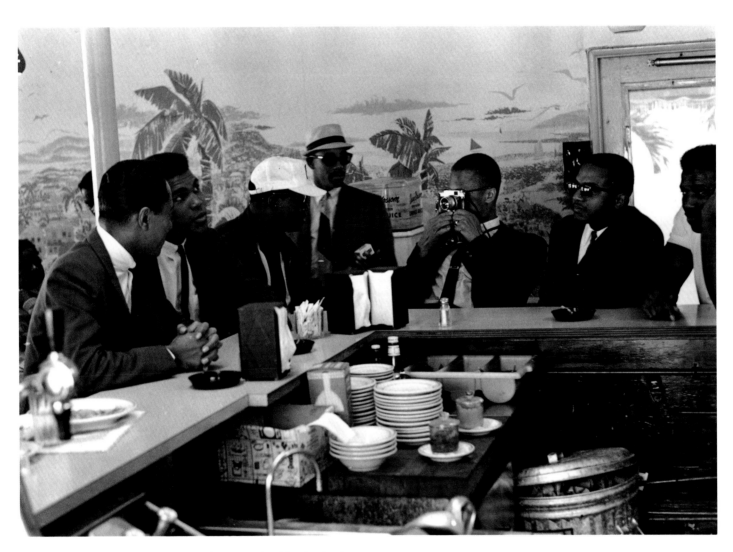

Miami, 1964. Being photographed by Malcolm X.

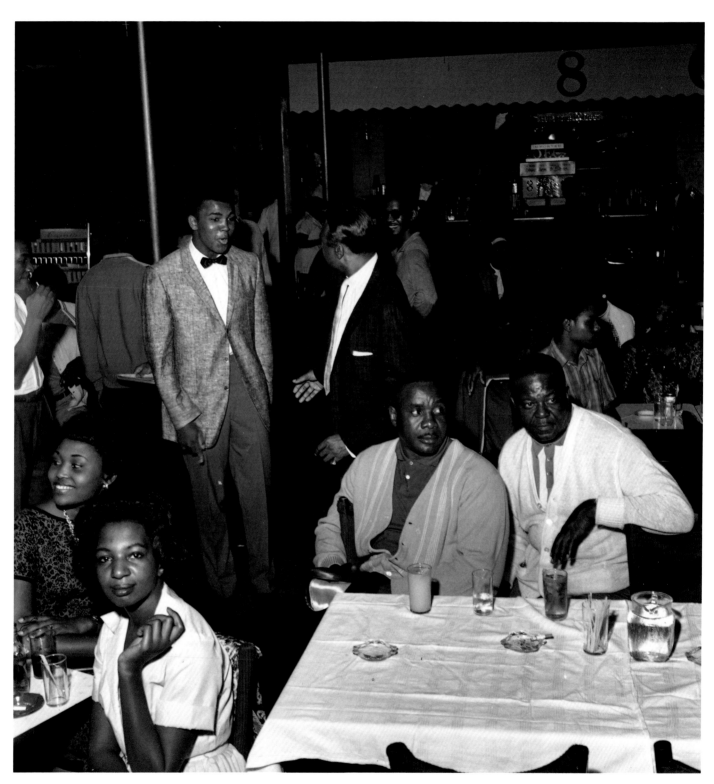

Miami, 1963. Sneaking up on Sonny Liston.

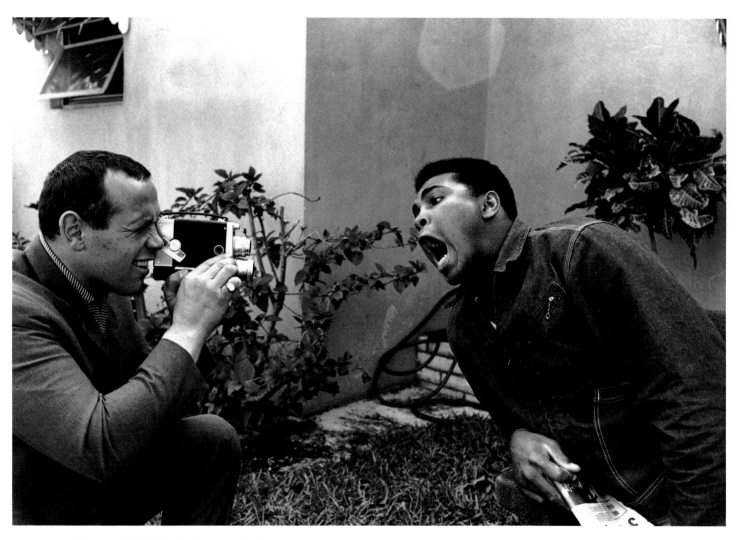

Miami, 1963. With Ingemar Johannson.

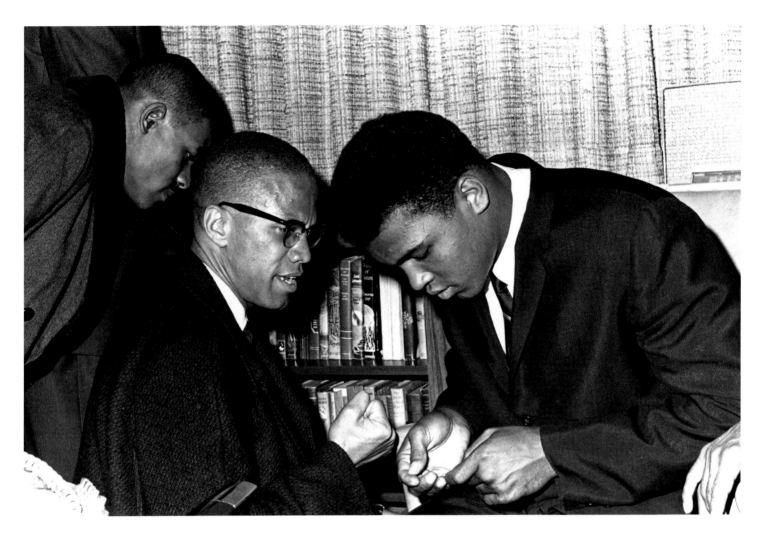

New York, 1963. With Malcolm X.

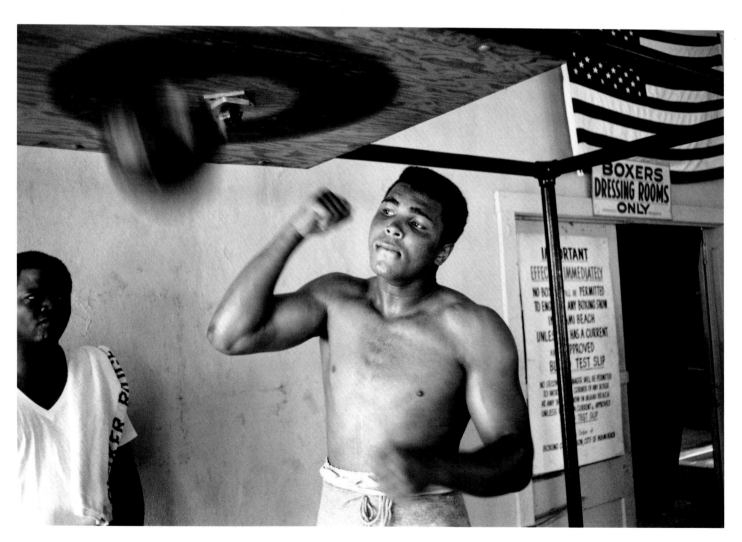

Miami, 1964. Training, as Drew Bundini Brown looks on.

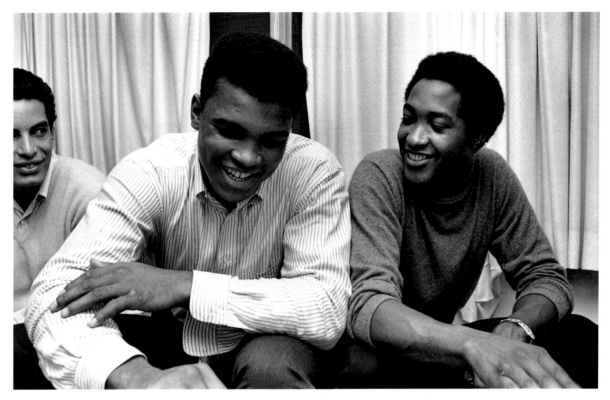

Miami, 1964.
With Sam Cooke.

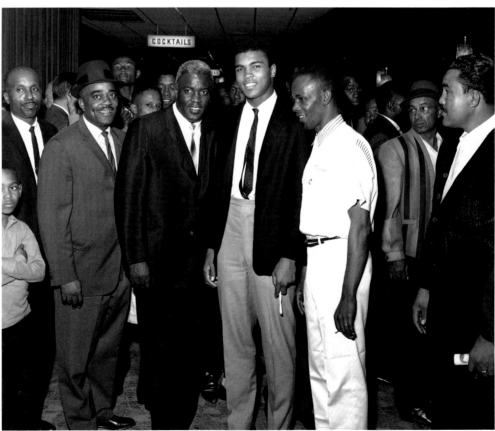

Los Angeles, 1963.
With Jackie Robinson.

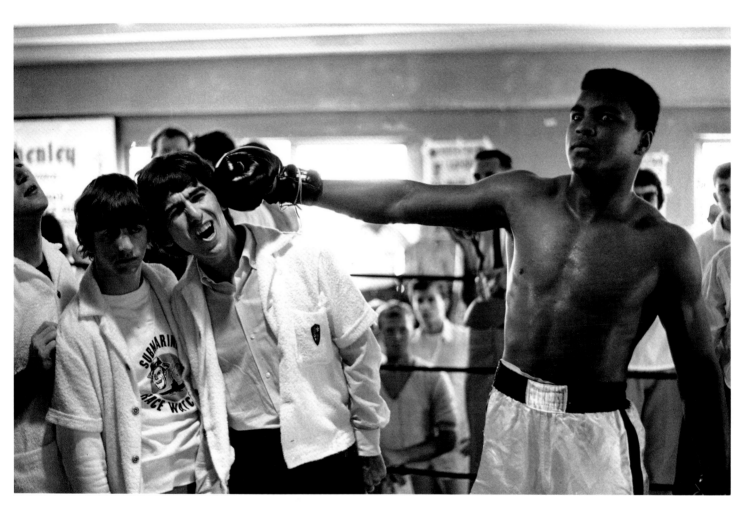

Miami, 1963. Playing around with the Beatles.

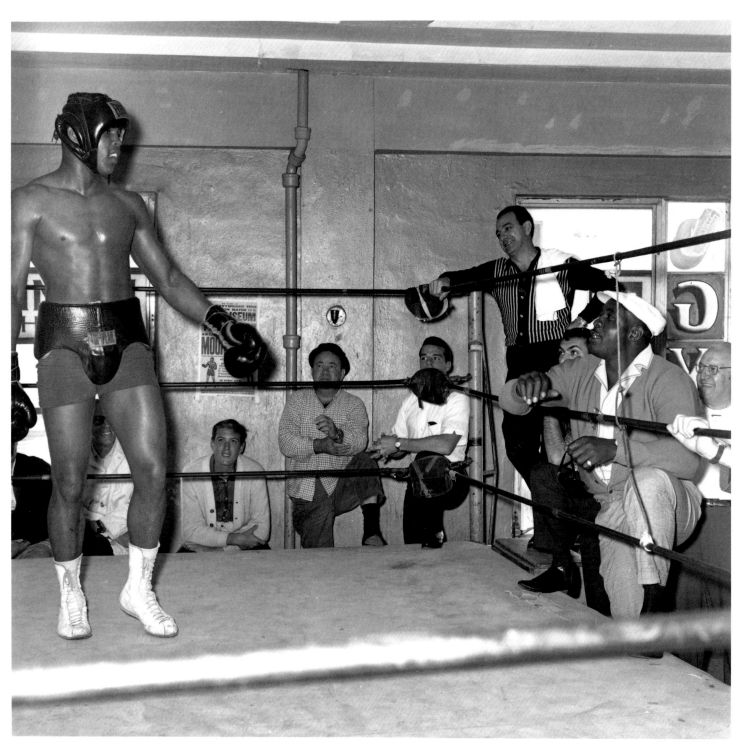

Miami, 1964. Training, with Sonny Liston at ringside.

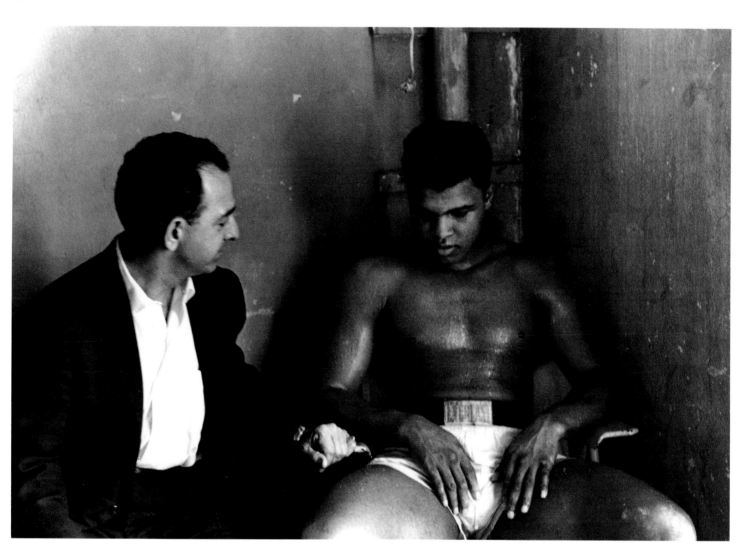

Miami, 1964. With Angelo Dundee.

Miami, 1964. Being photographed by Malcolm X.

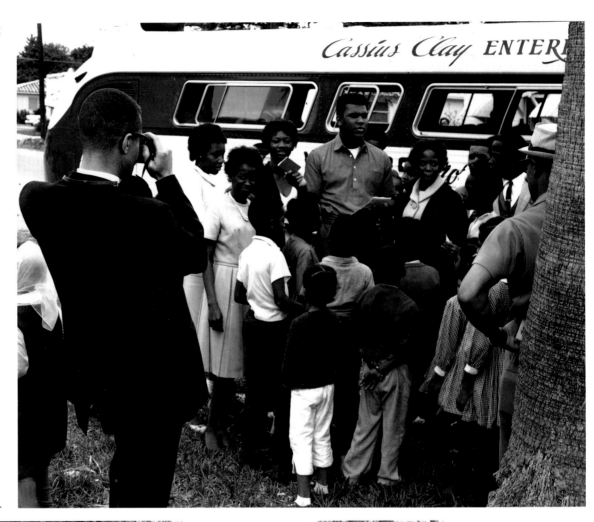

Miami, 1964.

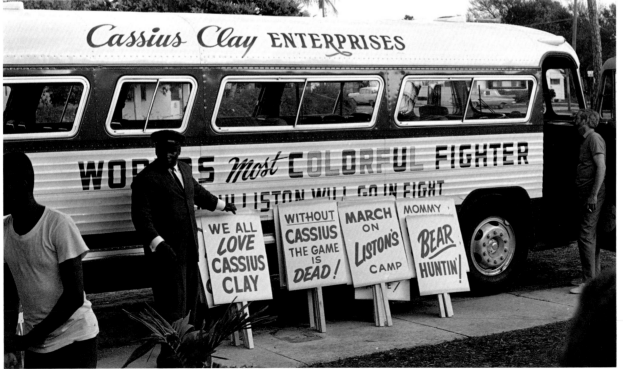

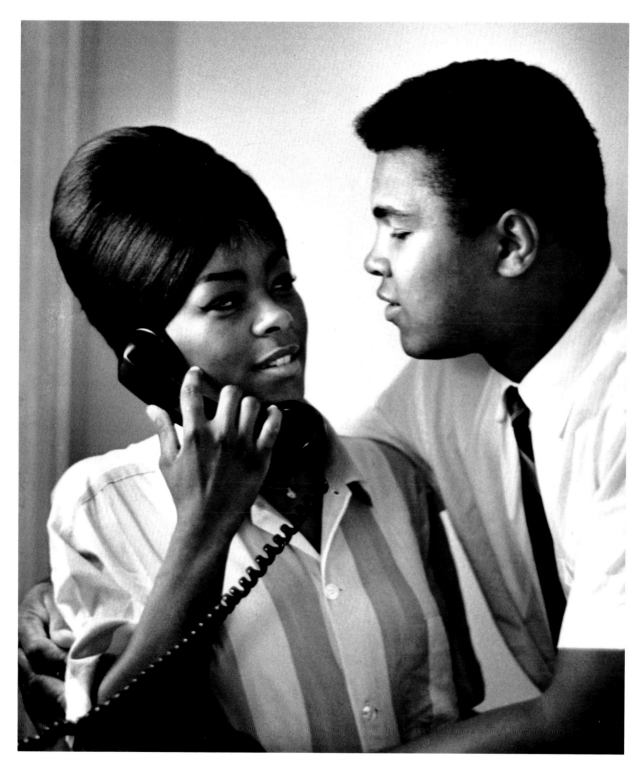

Miami, 1964. With his first wife, Sonji Clay.

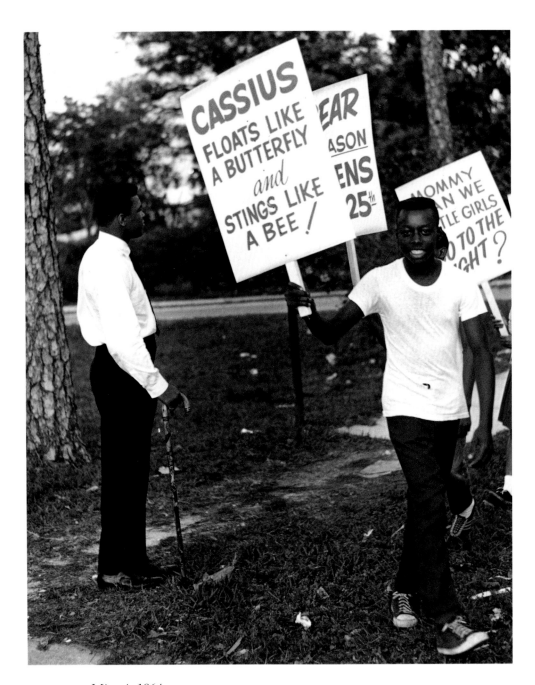

Miami, 1964.

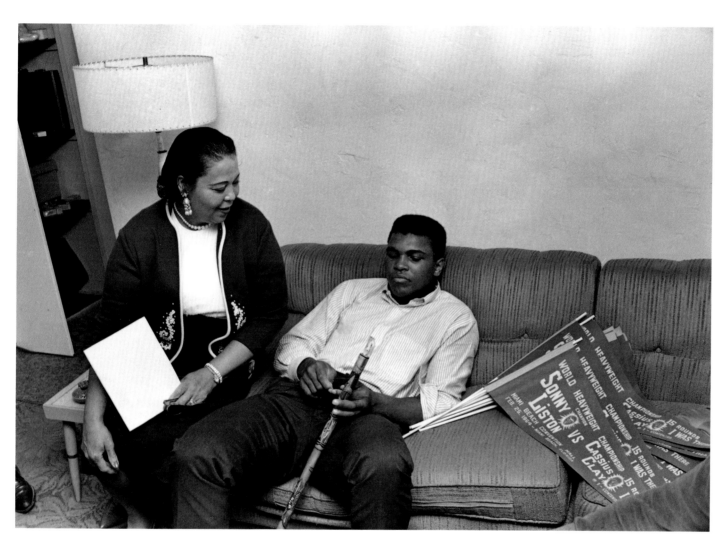

Miami, 1964. With his mother, Odessa Clay.

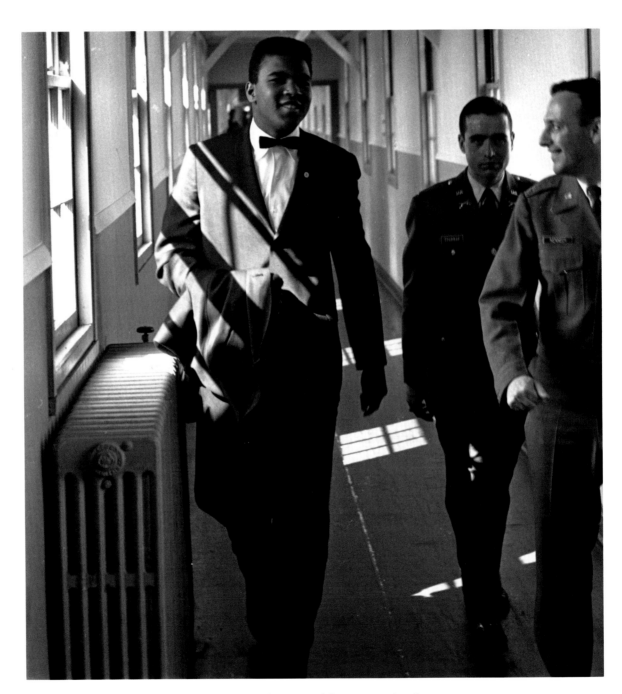

Louisville, 1964. Before his military qualifying examination.

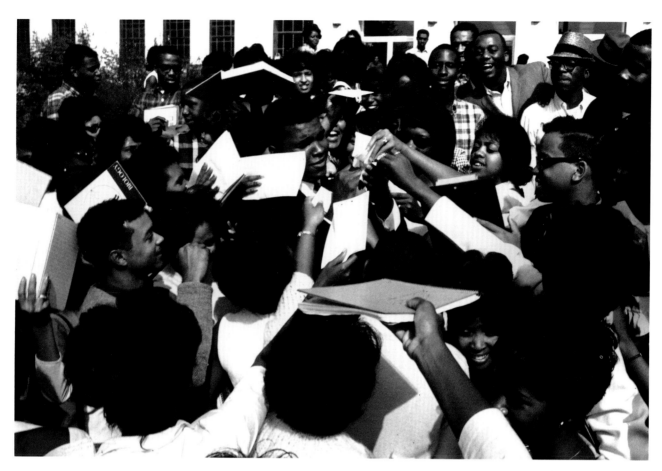

Nashville, 1964.
Surrounded by students at
Tennessee A & I.

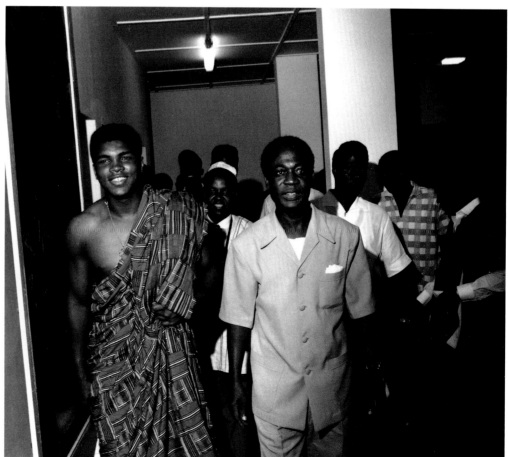

Ghana, 1964. With
President Kwame
Nkrumah.

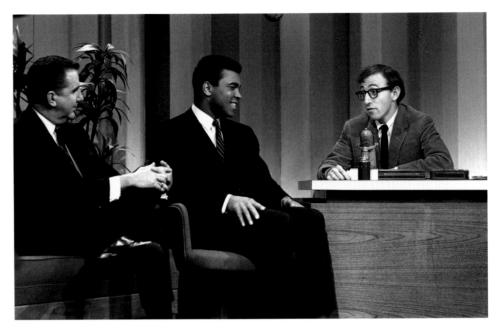

New York, 1964. On "The
Tonight Show" with guest host
Woody Allen and Ed
McMahon.

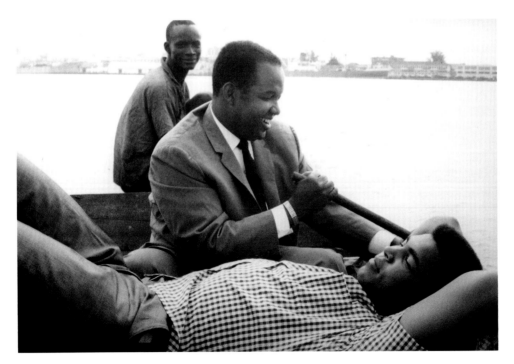

Egypt, 1964. On the Nile,
with Herbert Muhammad.

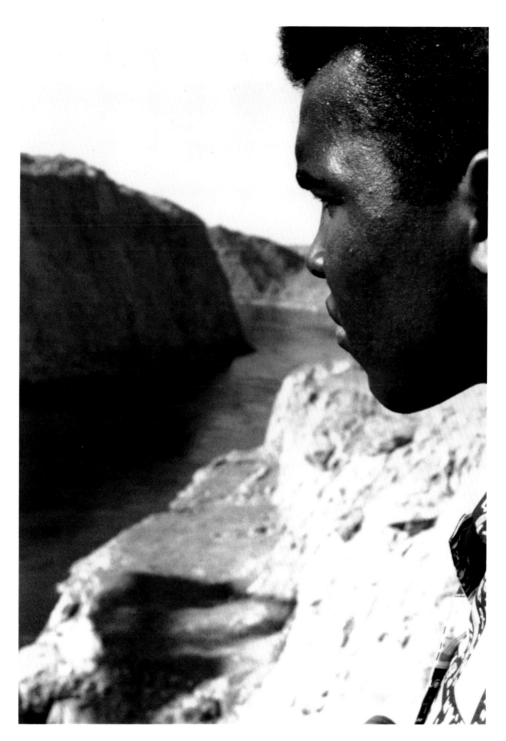

Egypt, 1964.

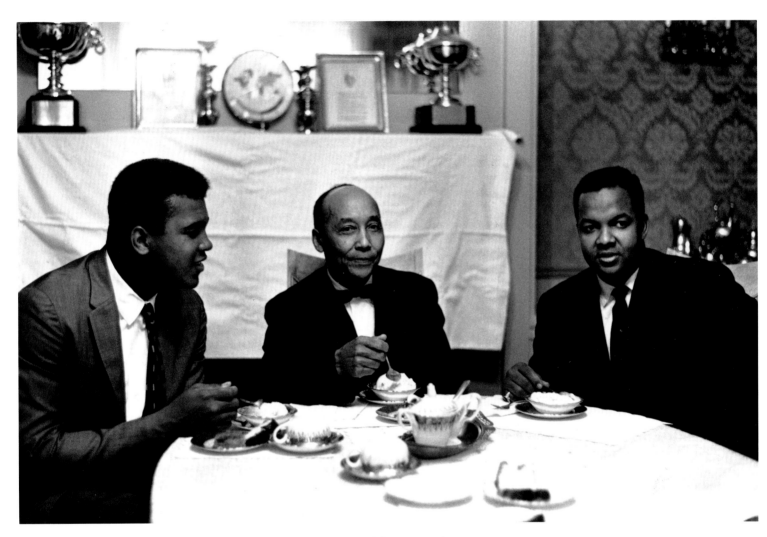

Chicago, 1964. With Elijah Muhammad and Elijah's son, Herbert
Muhammad.

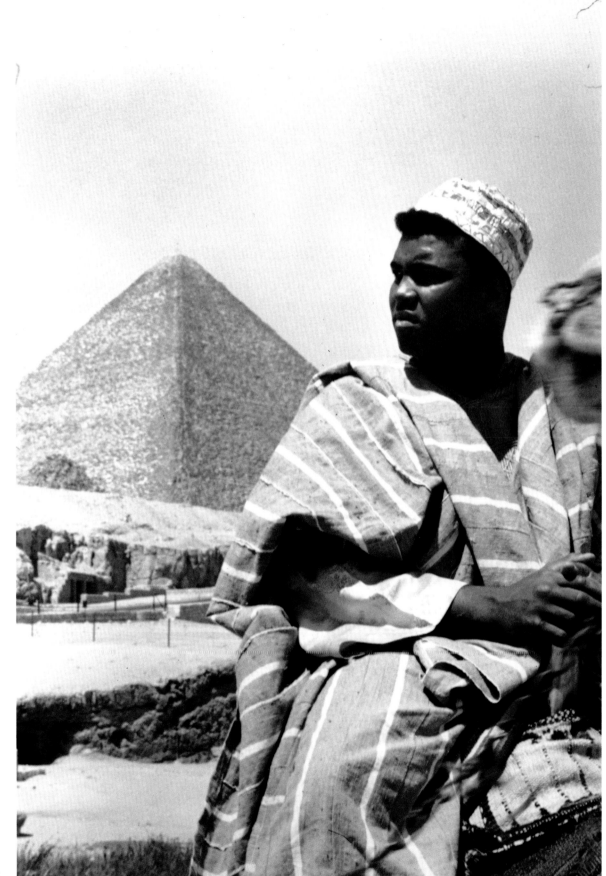

Egypt, 1964.

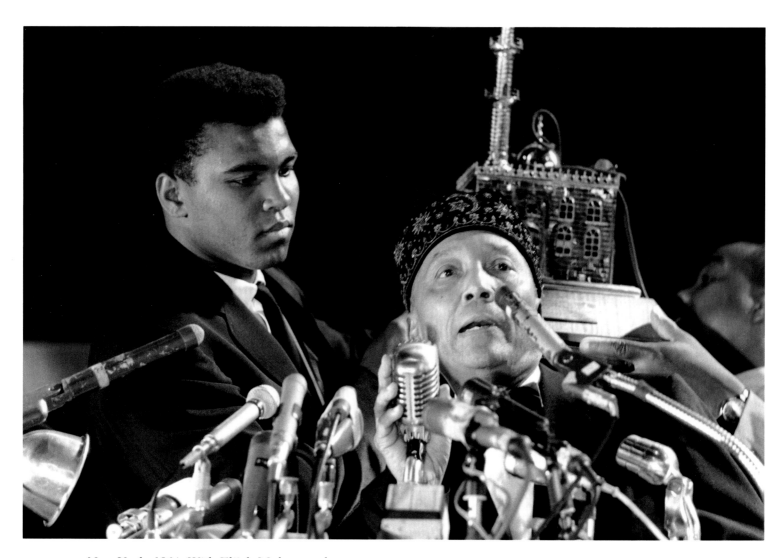

New York, 1964. With Elijah Muhammad.

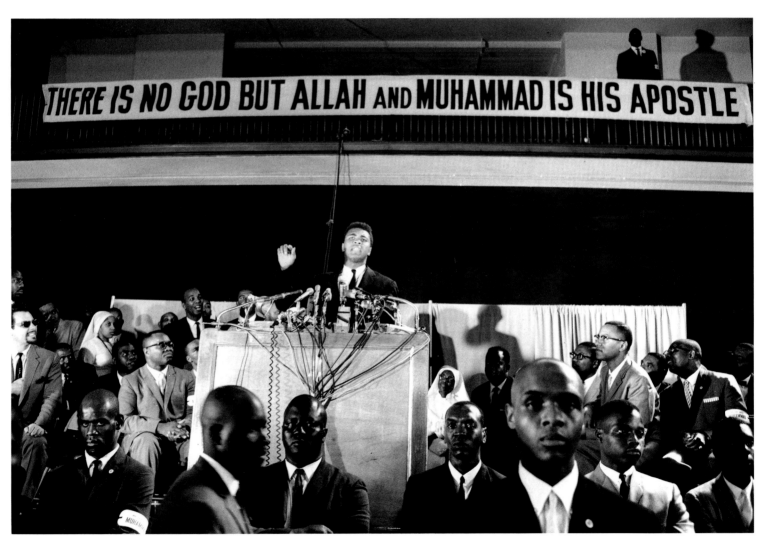

New York, 1964.

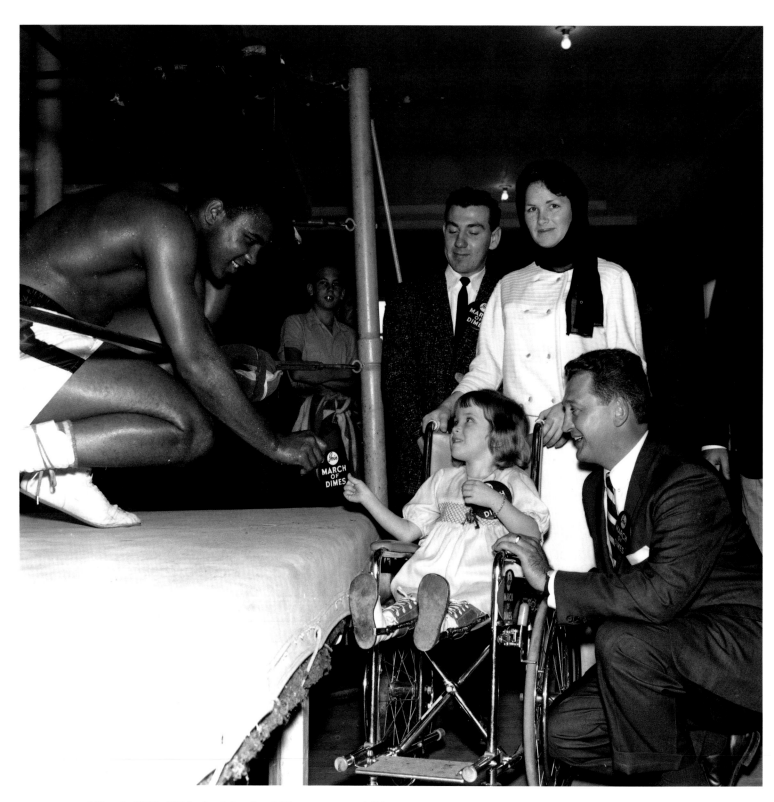

Miami, 1965. With the March of Dimes poster child.

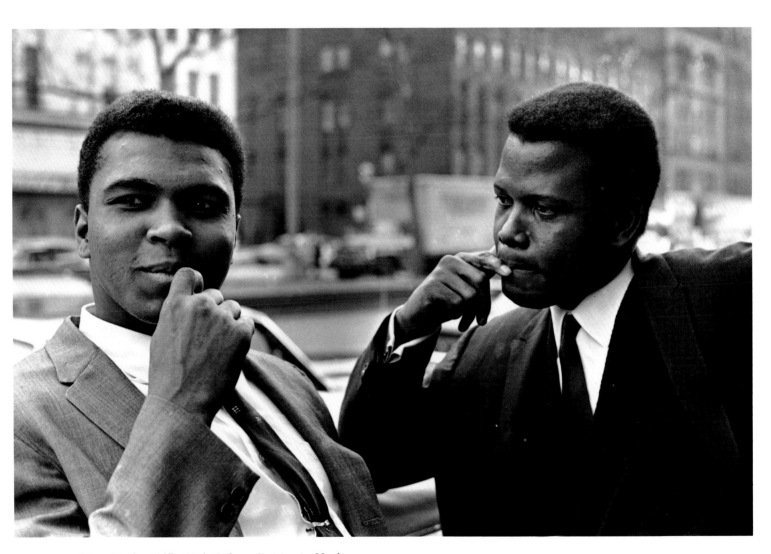

New York, 1965. With Sidney Poitier in Harlem.

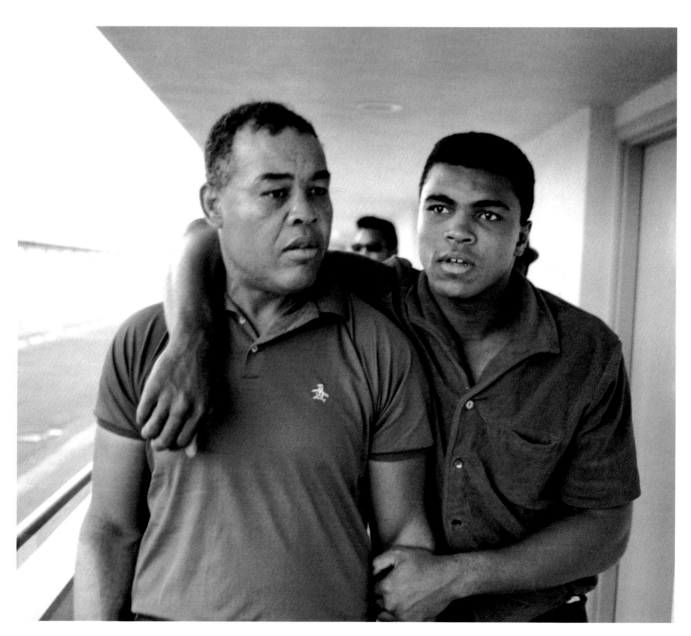

Las Vegas, 1965. With Joe Louis.

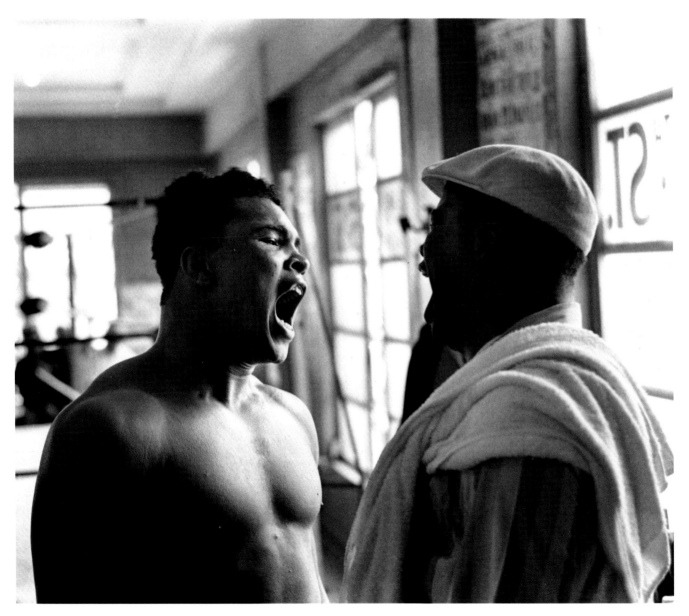

Miami, 1965. With Bundini Brown.

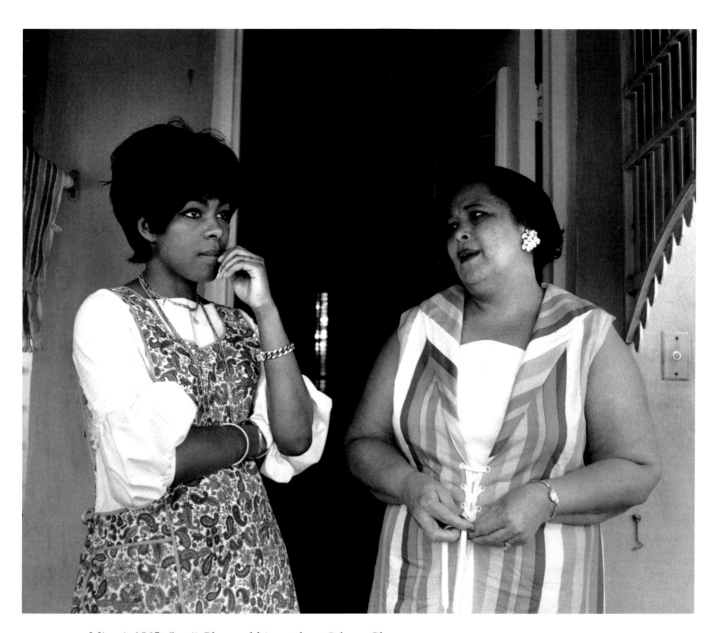

Miami, 1965. Sonji Clay and his mother, Odessa Clay.

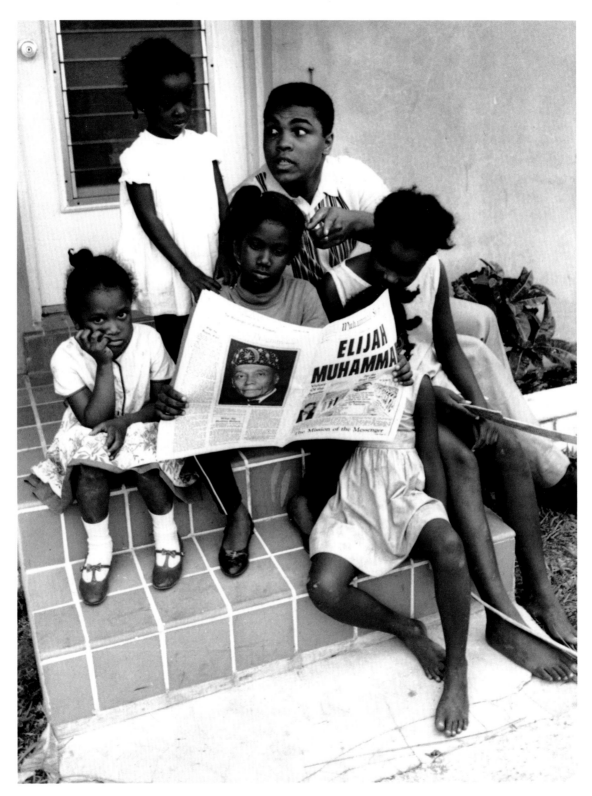

Miami, 1965.

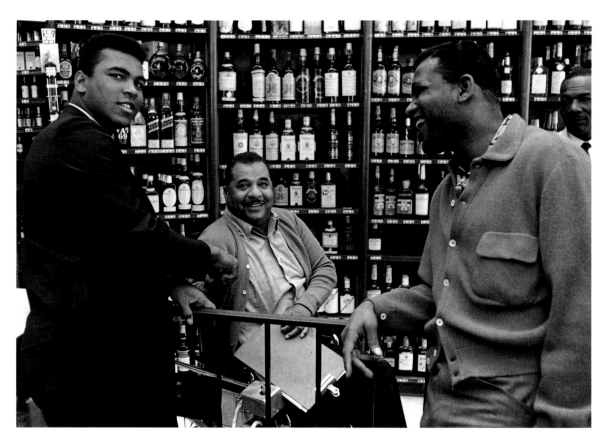

New York, 1965. With Sugar Ray Robinson (*right*), visiting Roy
Campanella at his liquor store in Harlem.

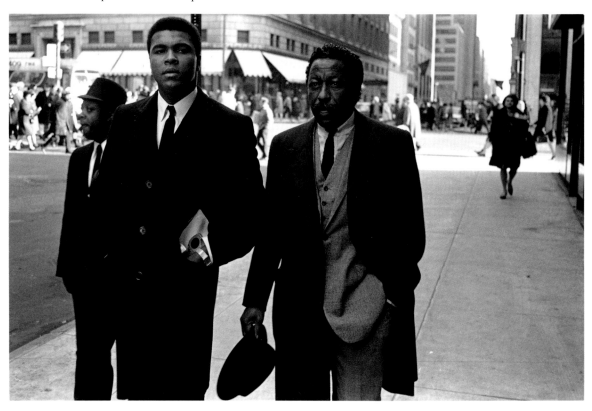

New York, 1965. With Gordon Parks.

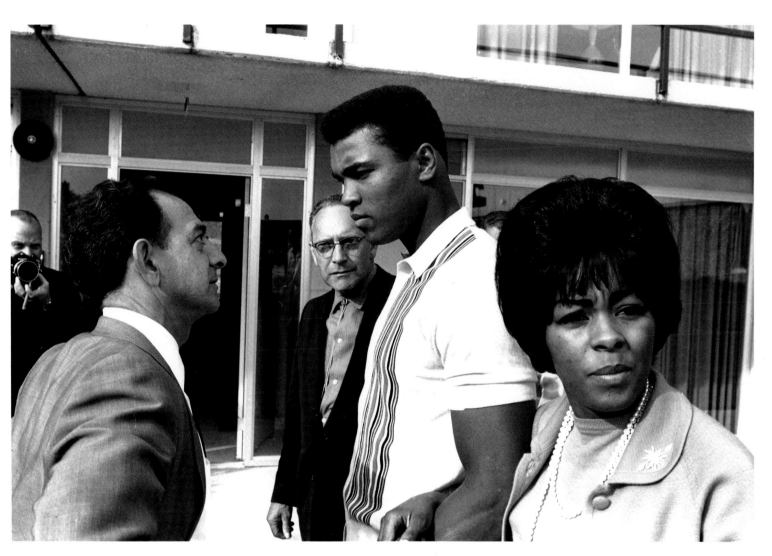

Lewiston, Maine, 1965 With Angelo Dundee (*left*) and Sonji Clay.

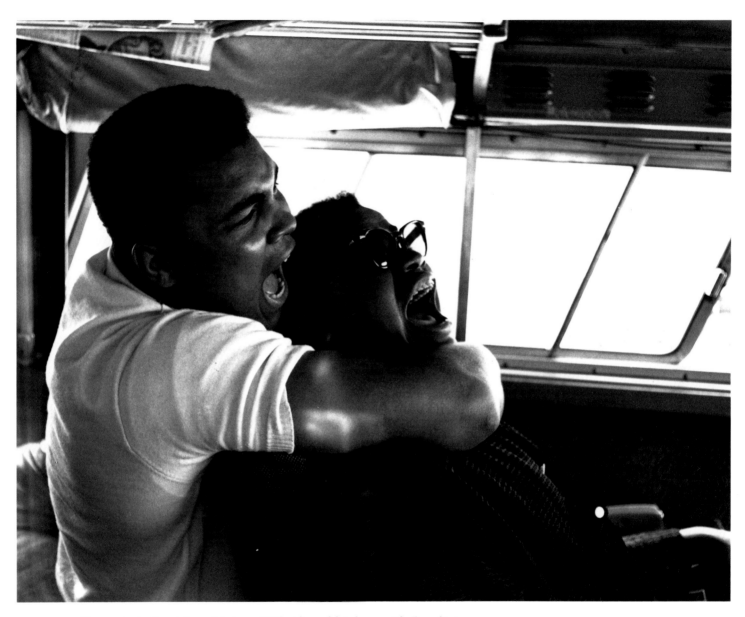

En route to Lewiston, Maine, 1965. Aboard his bus, with Bundini
Brown, on their way to the second Sonny Liston fight.

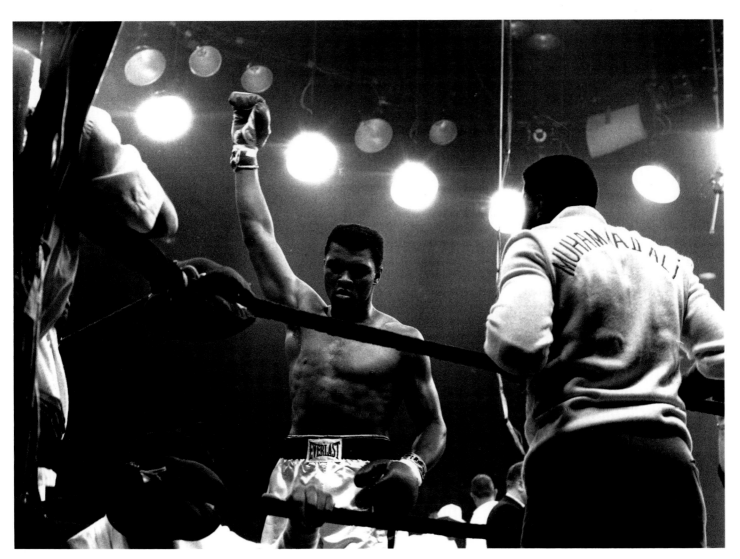

Lewiston, Maine, 1965. After knocking out Sonny Liston.

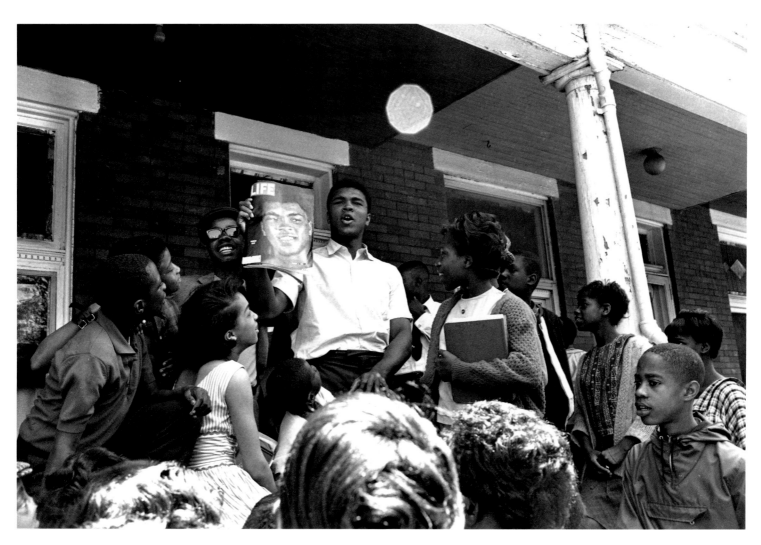

Springfield, Massachusetts, 1965.

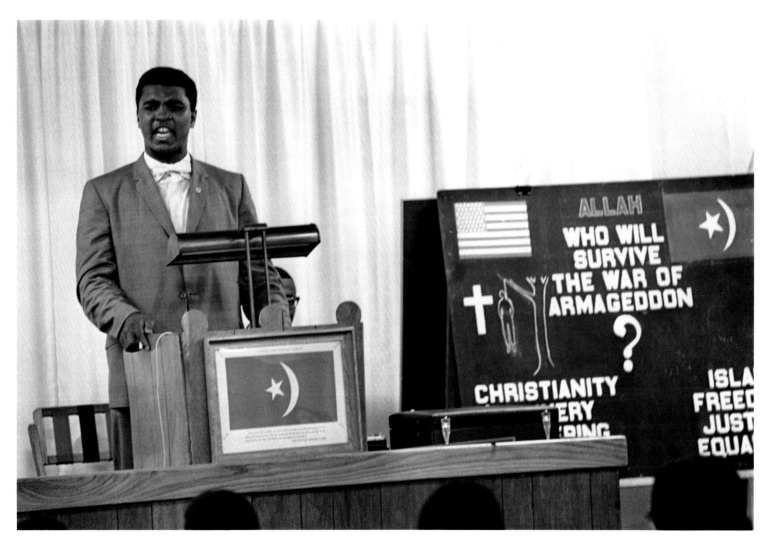

Springfield, Massachusetts, 1965. Preaching for the Nation of Islam.

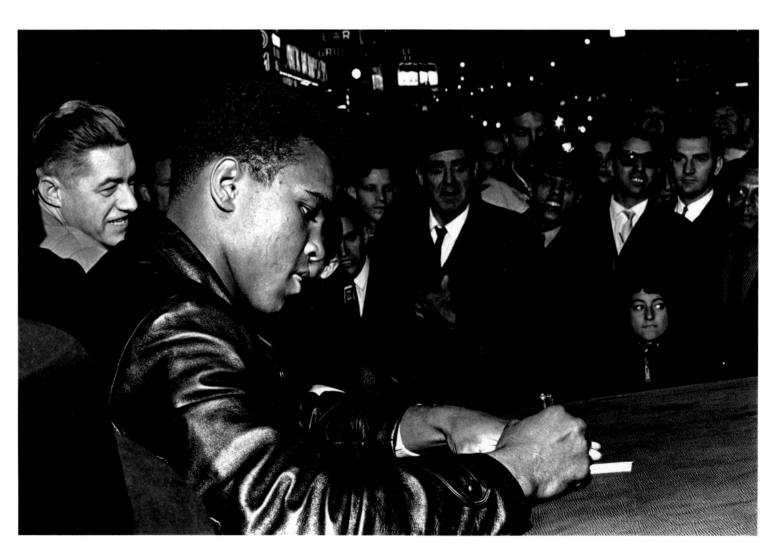

Sweden, 1965.

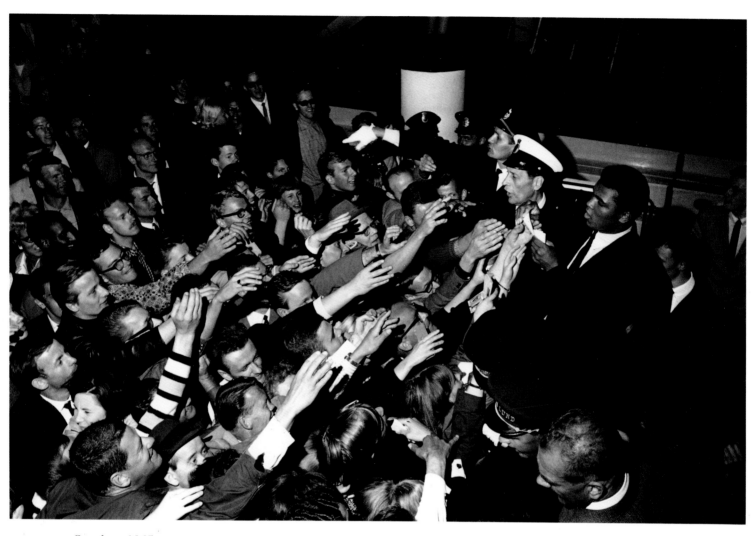

Sweden, 1965.

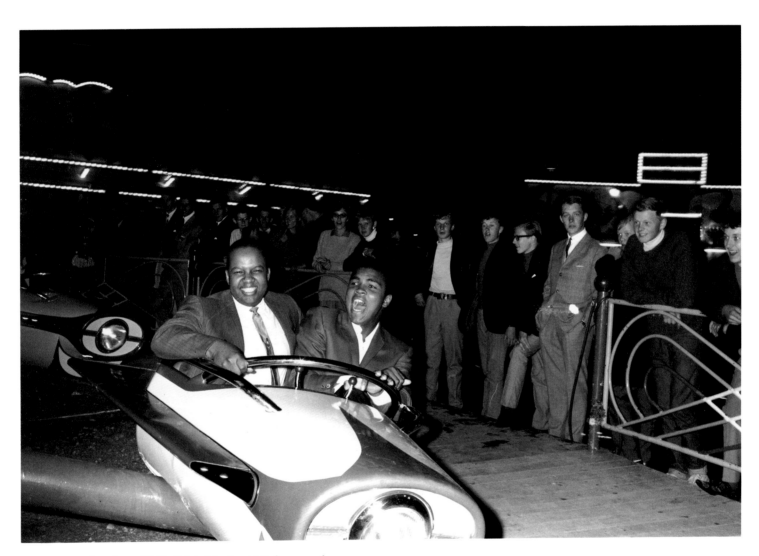

Sweden, 1965. With Herbert Muhammad.

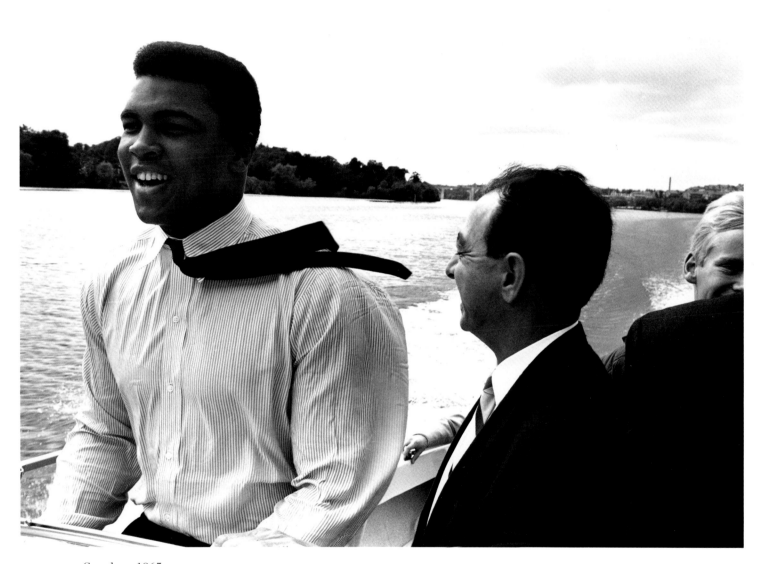

Sweden, 1965.

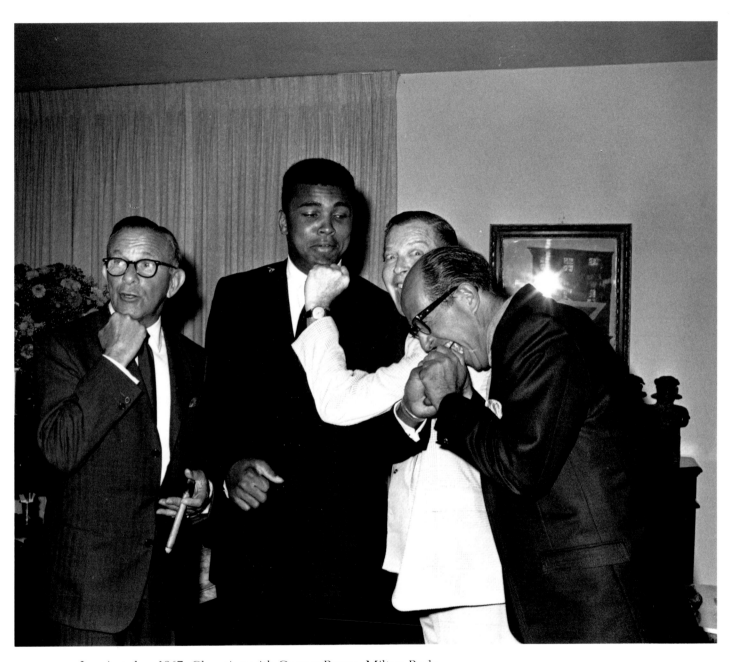

Los Angeles, 1967. Clowning with George Burns, Milton Berle, and Phil Silvers.

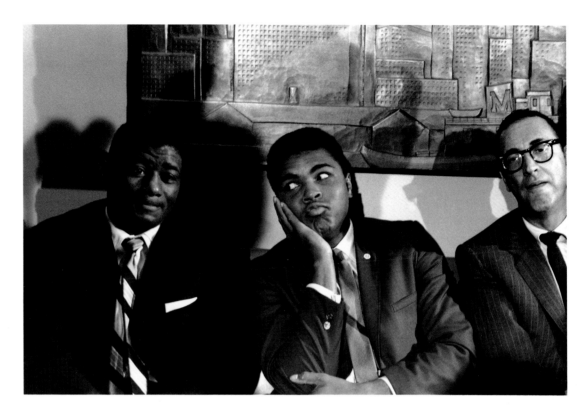

New York, 1966. With Floyd Patterson and publicist Harold
Conrad, on the day they signed to fight.

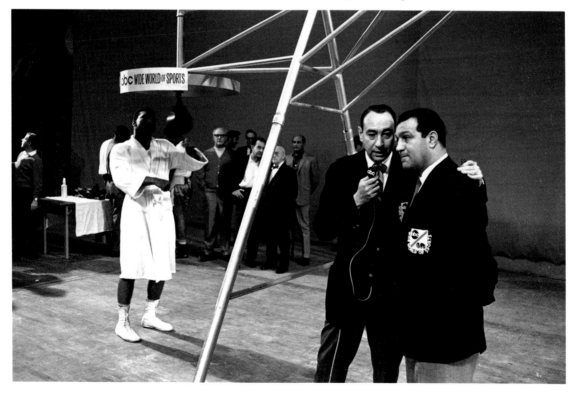

Las Vegas, 1966. Preparing to meet Floyd Patterson, as Howard
Cosell and Rocky Marciano discuss Ali's prospects.

Louisville, 1967. Cassius Clay, Sr.

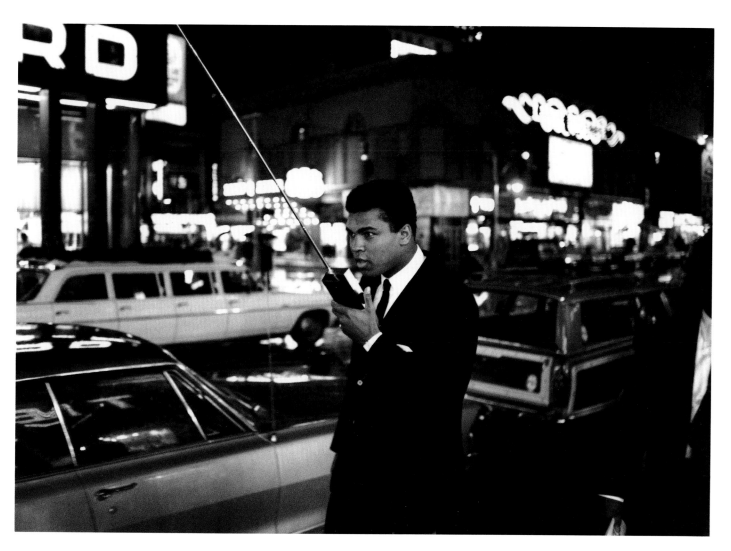

New York, 1967.

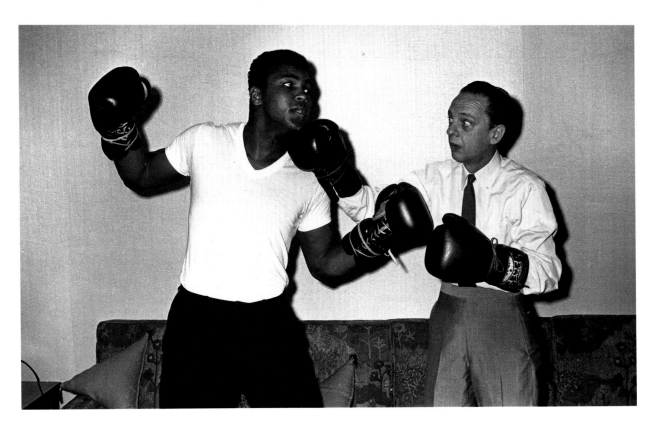

Houston, 1966. With Don Knotts.

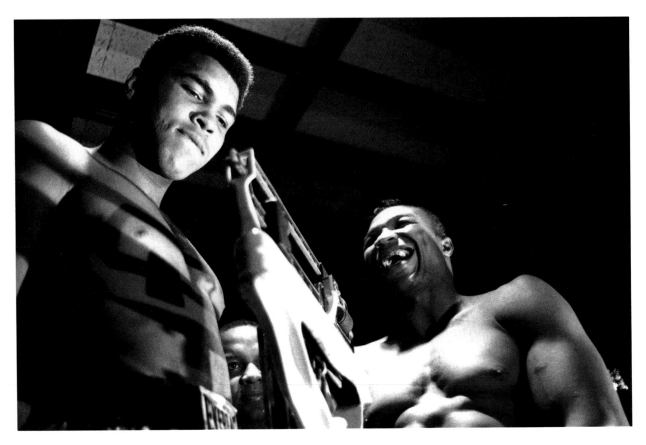

Houston, 1966. With Cleveland Williams at the prefight weigh-in.

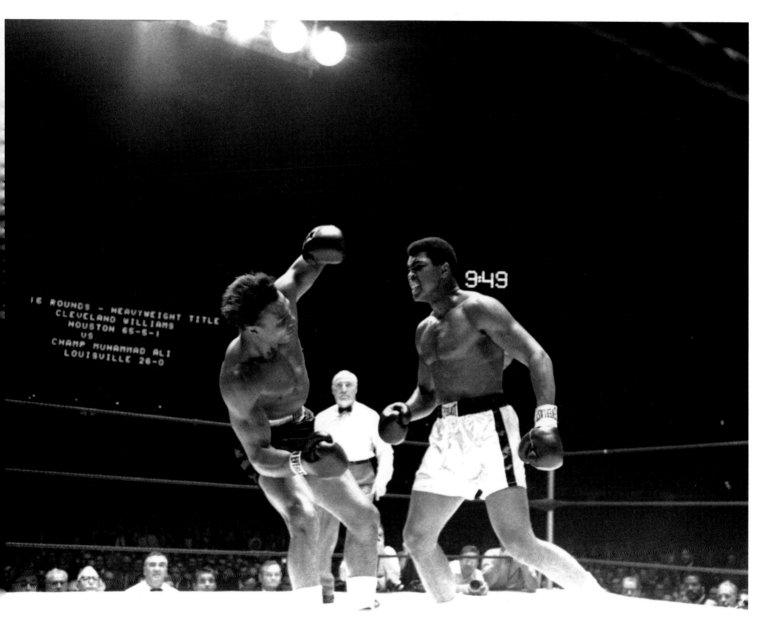

Houston, 1966. Knocking down Cleveland Williams.

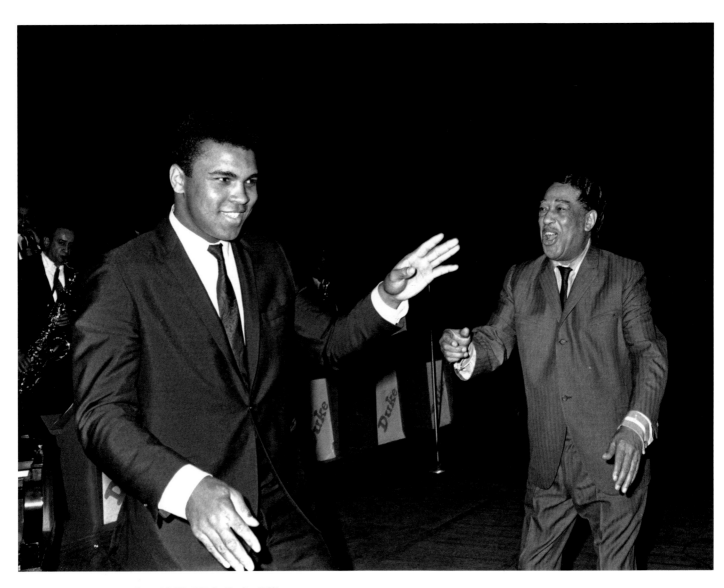

Los Angeles, 1967. With Duke Ellington.

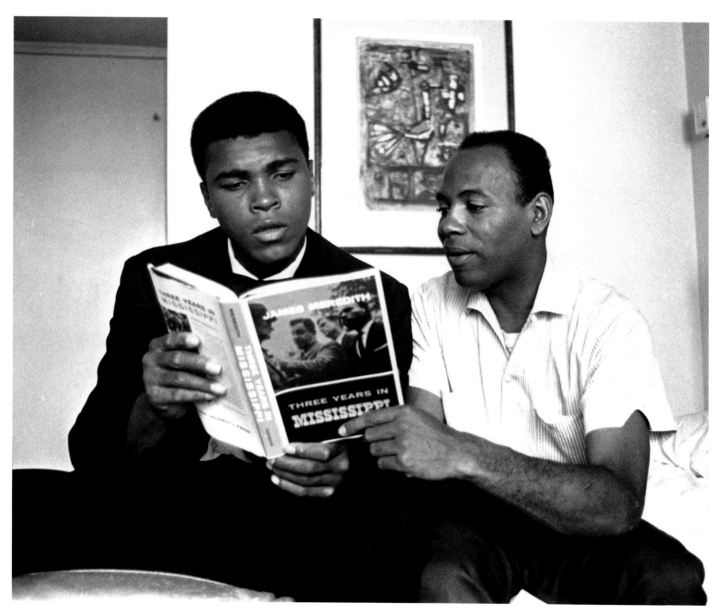

New York, 1966. With James Meredith.

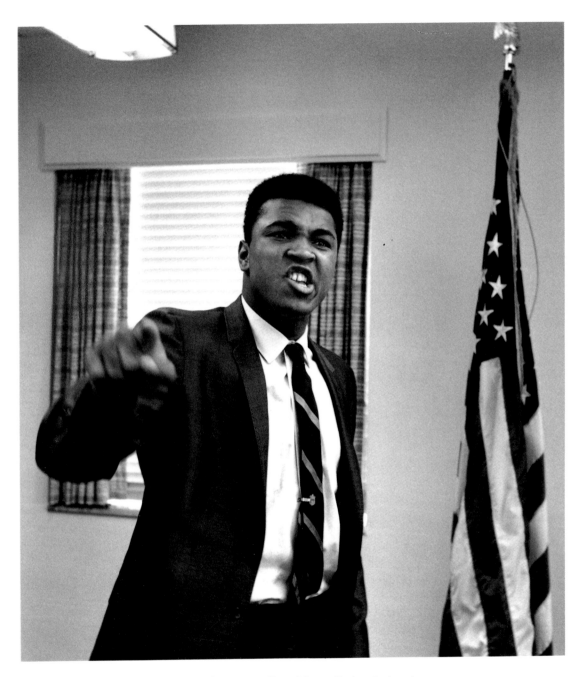

Houston, 1967. The day he was indicted for refusing induction
into the armed forces.

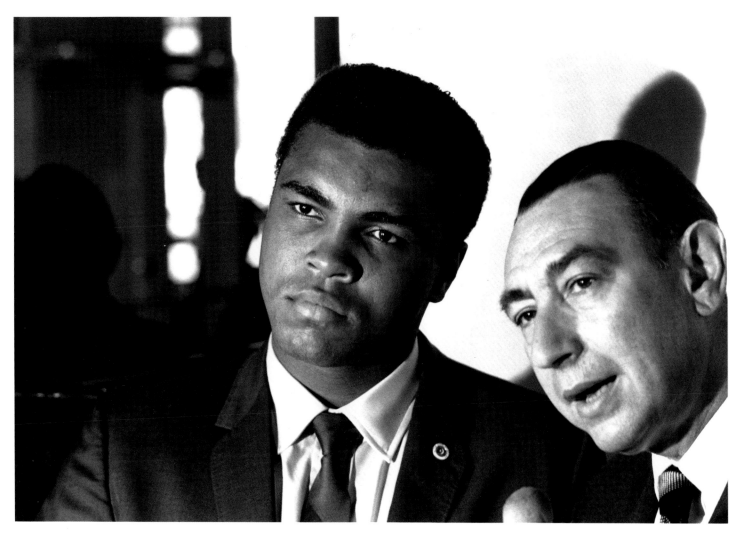

Houston, 1967. Being interviewed by Howard Cosell after being indicted.

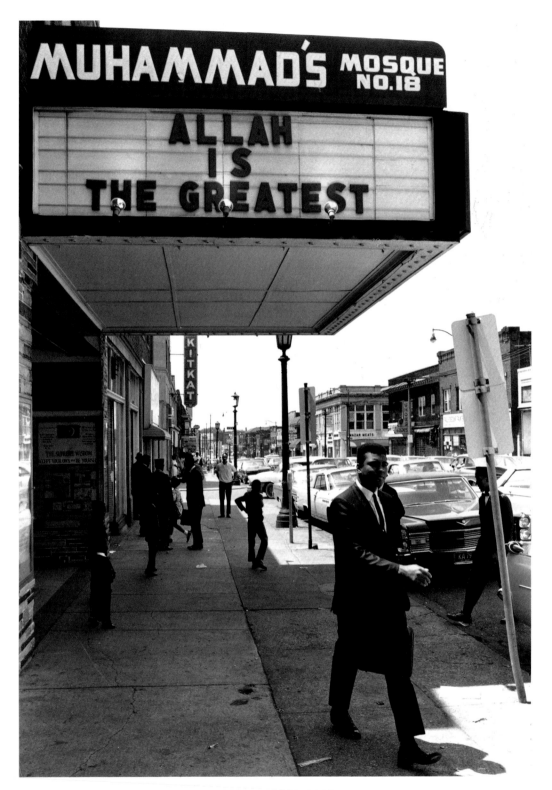

Cleveland, 1967.

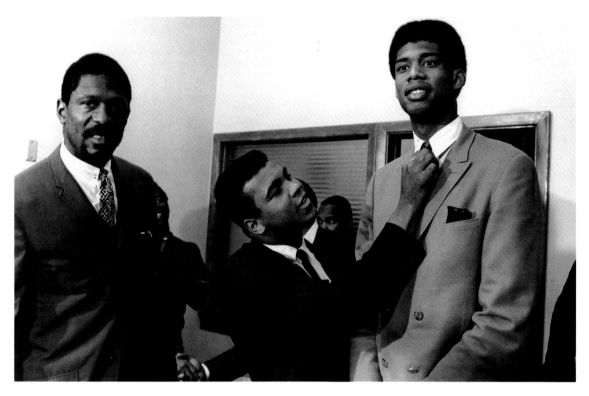

Cleveland, 1967. Straightening Lew Alcindor's tie, as Bill Russell looks on.

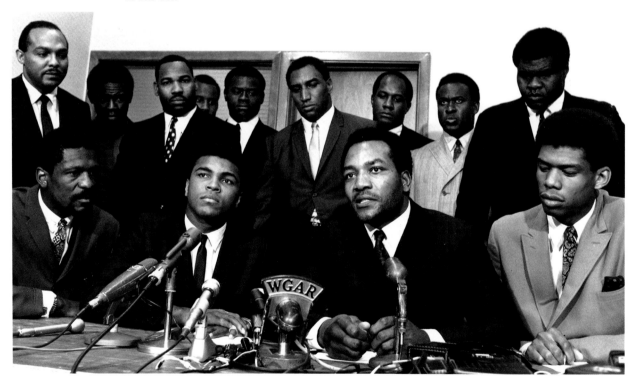

Cleveland, 1967. Surrounded by supporters of his decision to refuse induction into the Army; *(front row)* with Bill Russell, Jim Brown, and Lew Alcindor; *(back row, left to right)* Cleveland Mayor Carl Stokes, Walter Beach, Bobby Mitchell, Lorenzo Ashley, Sidney Williams, Curtis McClinton, Willie Davis, Jim Shorter, and John Wooten.

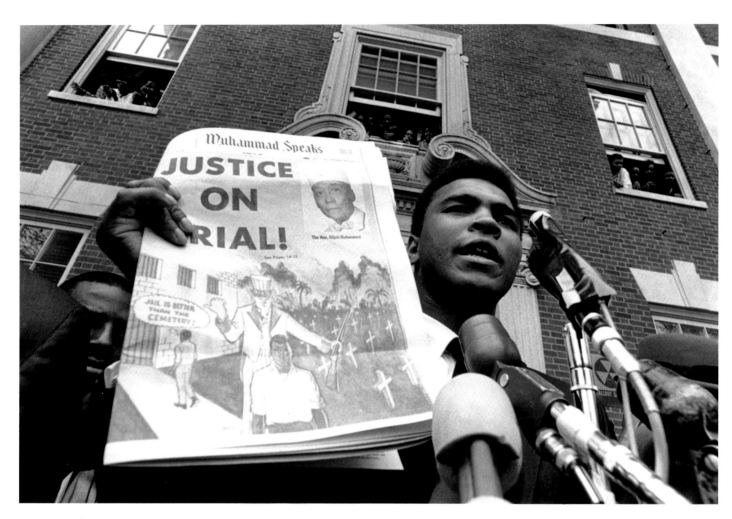

Washington, D.C., 1967. At Howard University.

Houston, 1967.

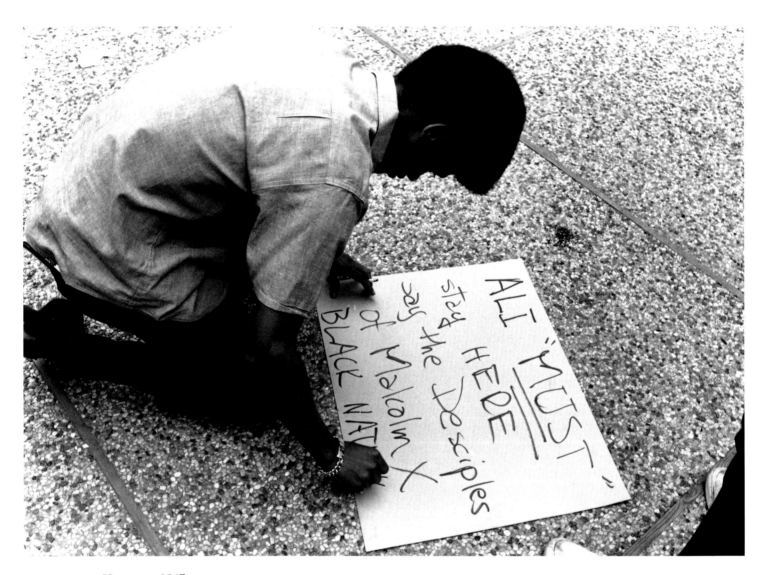

Houston, 1967.

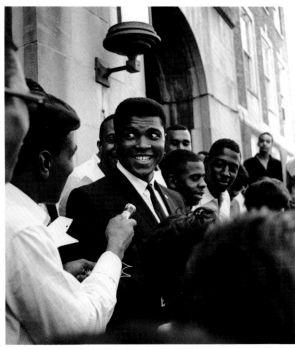

Washington, D.C., 1967. At
Howard University.

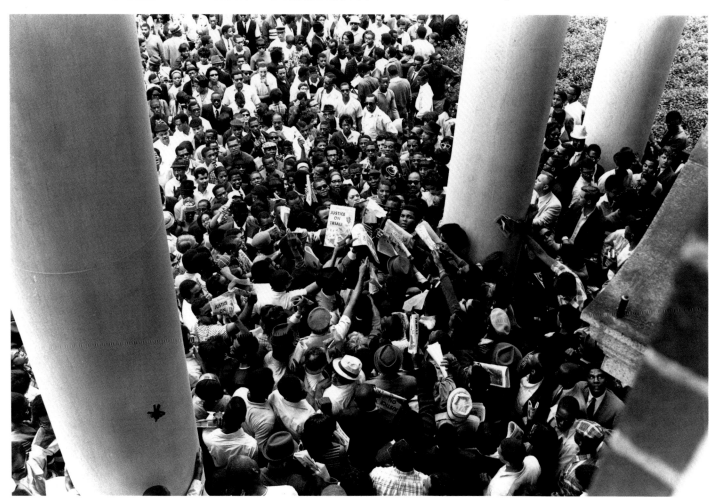

Washington, D.C., 1967. At Howard University.

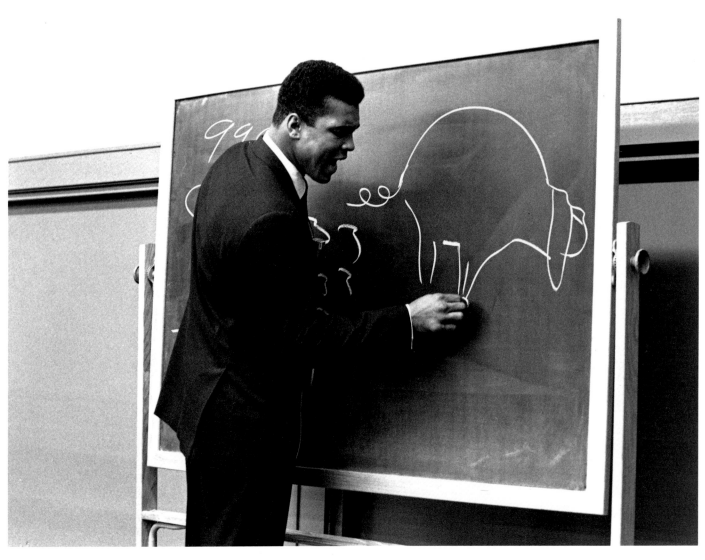

Baltimore, 1968. Explaining Muslim dietary restrictions.

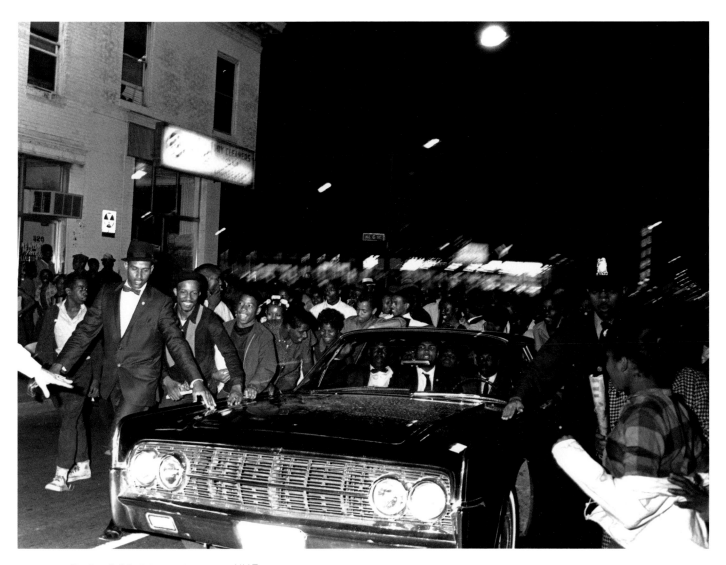

Springfield, Massachusetts, 1967.

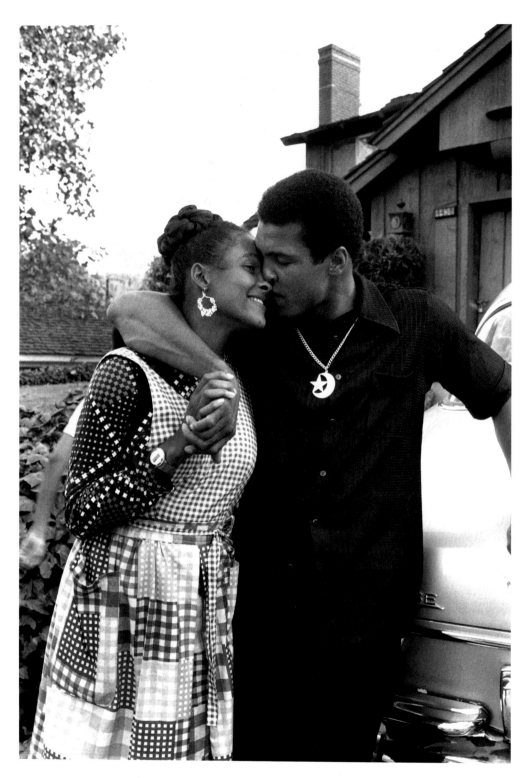

Los Angeles, 1968. With his second wife, Belinda Boyd Ali.

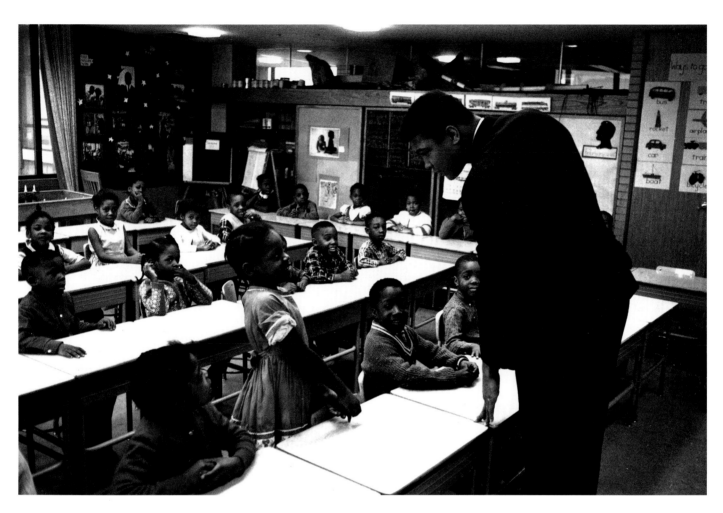

Chicago, 1969.

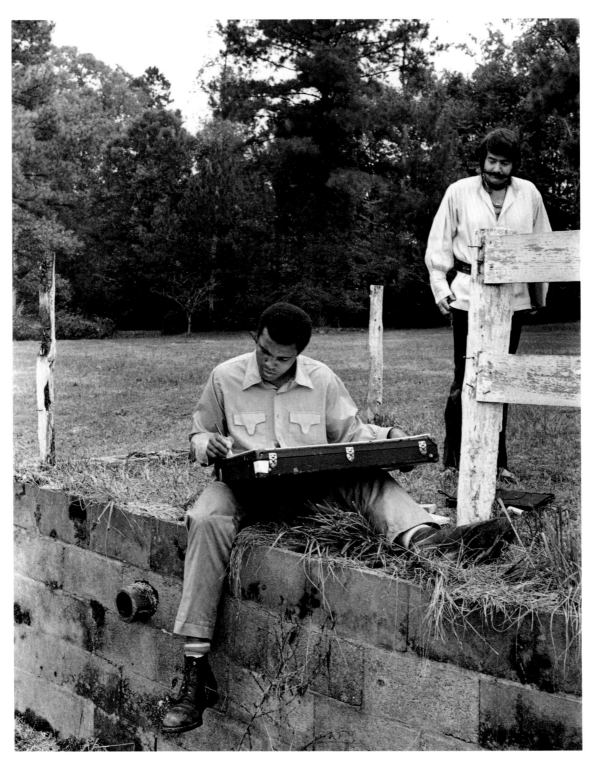
Atlanta, 1970. Drawing, as Leroy Neiman looks on.

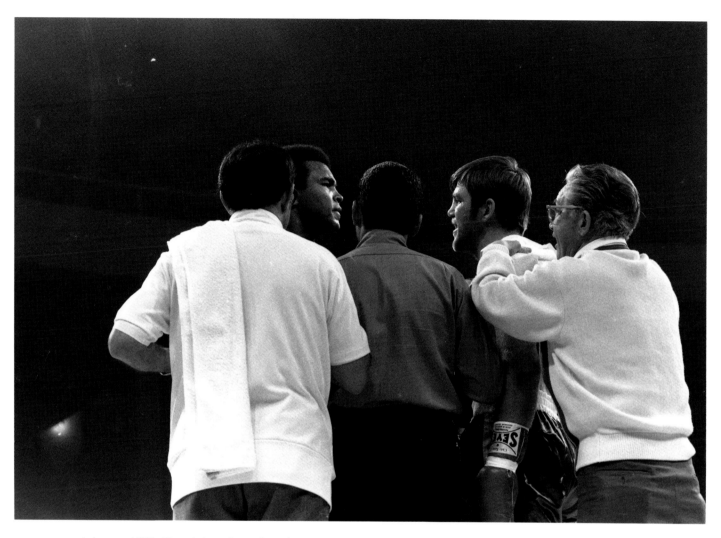

Atlanta, 1970. Receiving the referee's instructions before facing
Jerry Quarry, his first fight after his title and license were revoked.

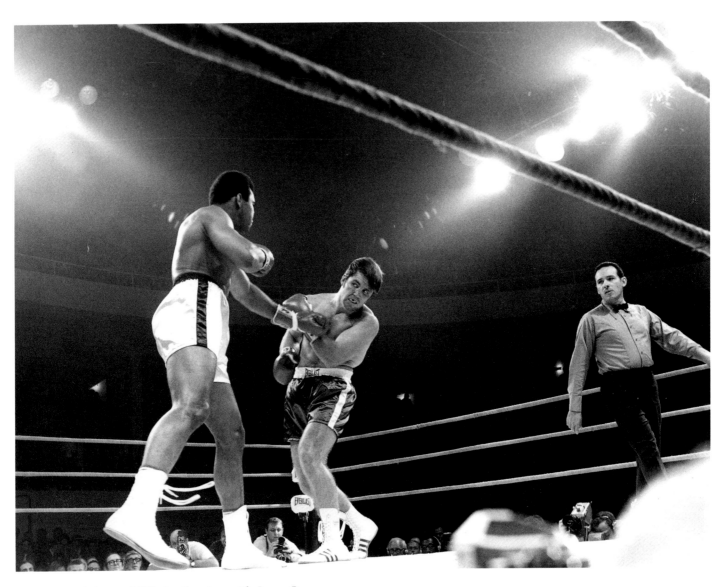

Atlanta, 1970. In the ring with Jerry Quarry.

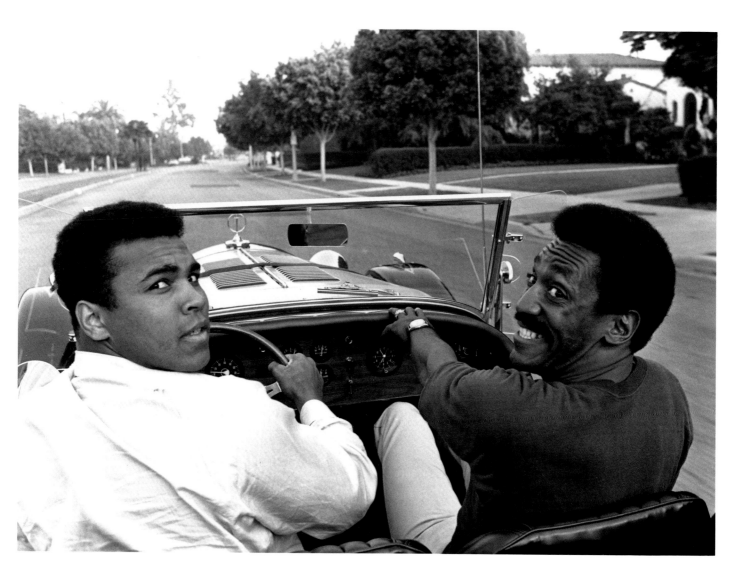

Los Angeles, 1970. With Bill Cosby.

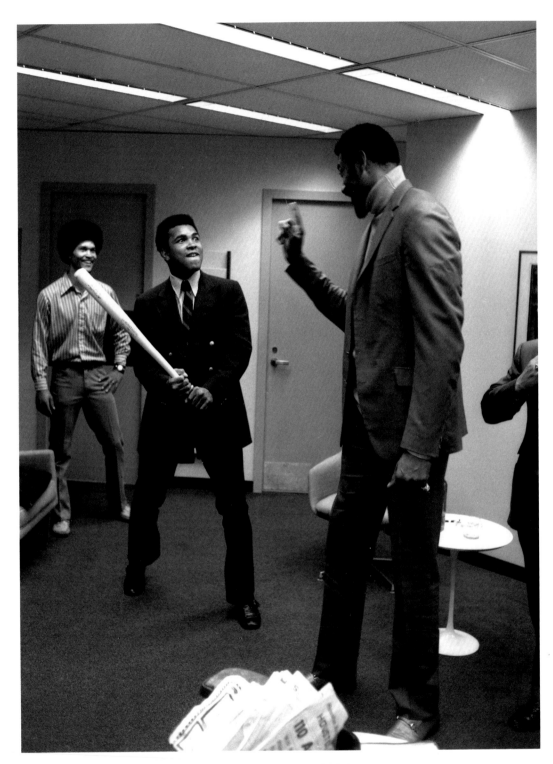

Houston, 1971. Taunting potential foe, Wilt Chamberlain.

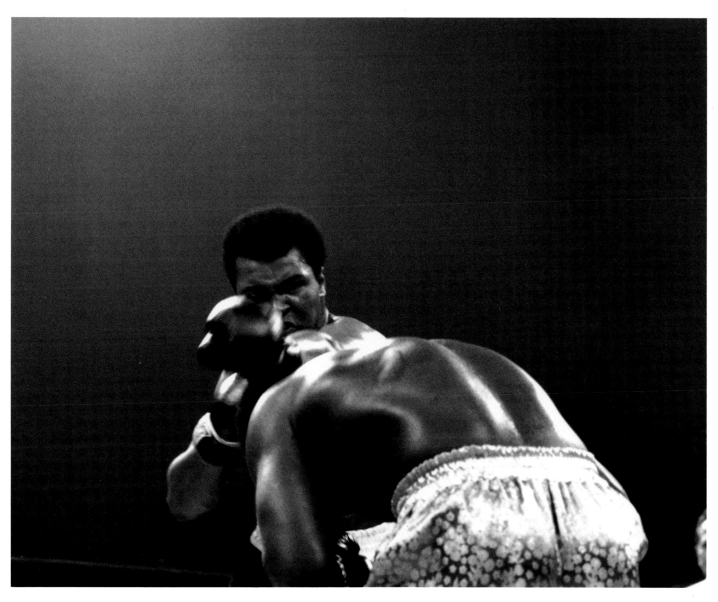

New York, 1971. In the ring with Joe Frazier.

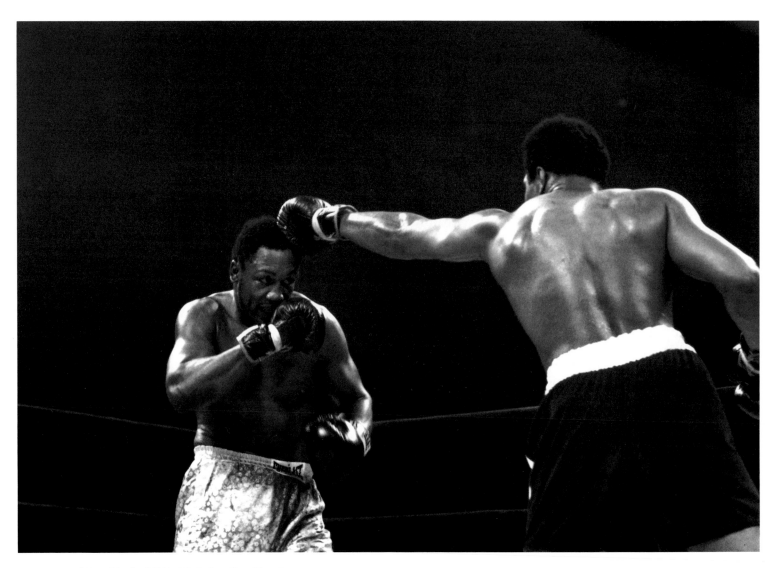

New York, 1971. Fighting Joe Frazier

New York, 1972.

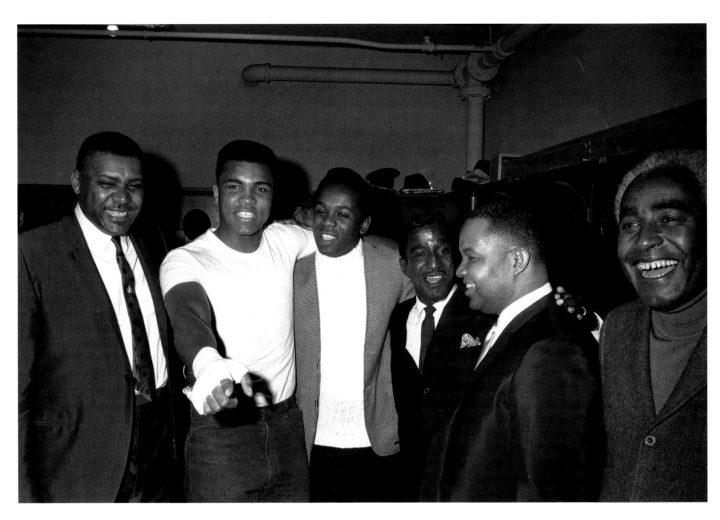

Cleveland, 1972. With Don King (sans hair), Lou Rawls, Sammy
Davis, Jr., Herbert Muhammad, and J. W. Alexander.

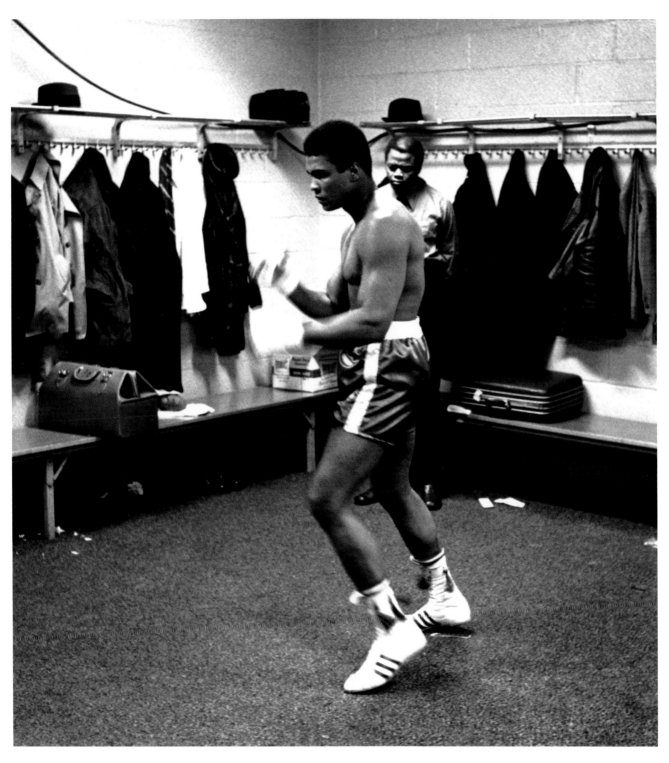

New York, 1972. In the dressing room, before his fight against
Oscar Bonavena.

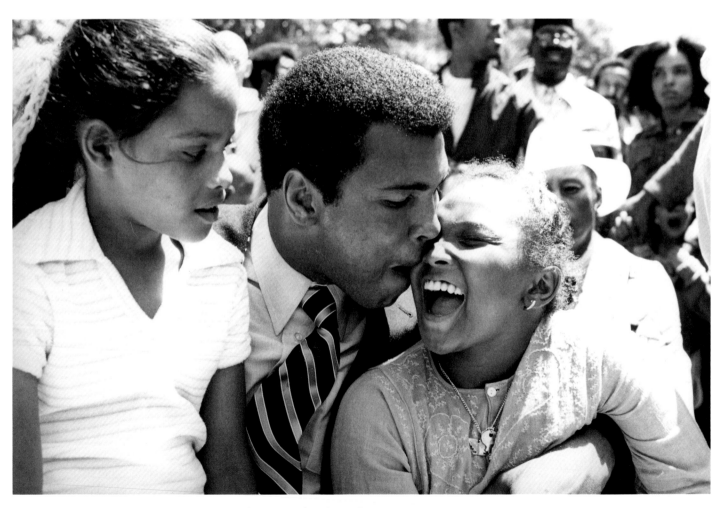

Chicago, 1972. With his daughters, Rasheeda and Maryum.

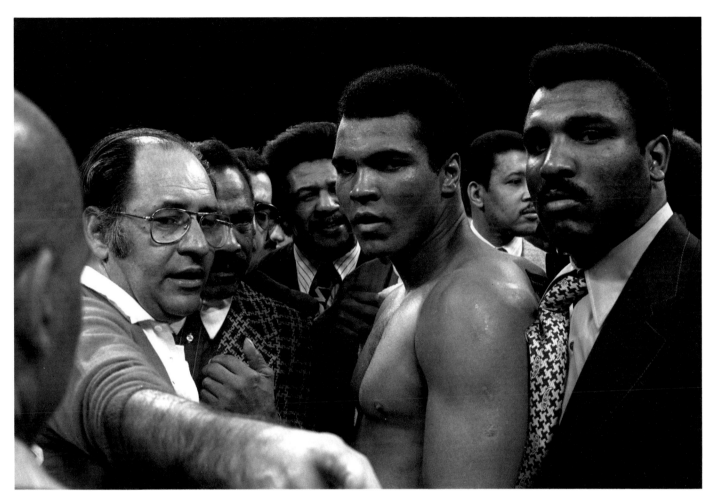

New York, 1972. With Ferdie Pacheco, Cassius Clay, Sr., and his
brother, Rahaman Ali, after fighting Floyd Patterson.

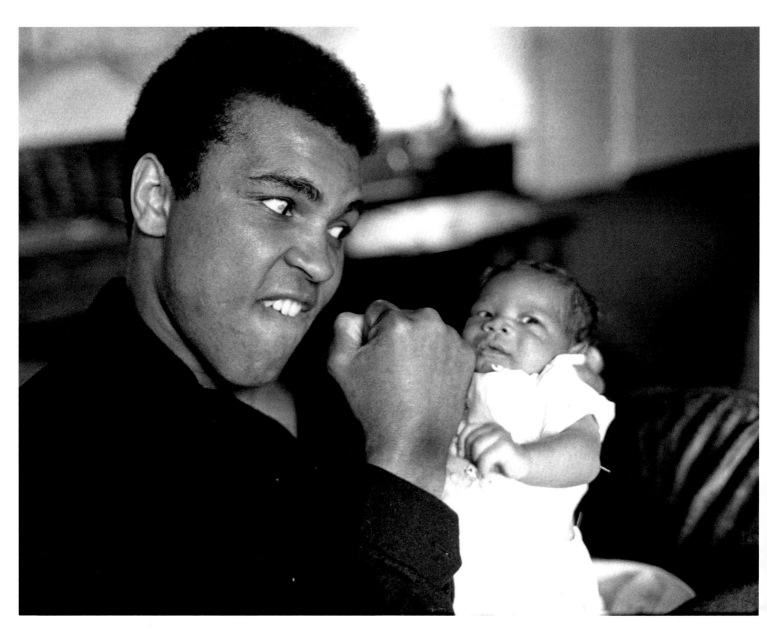

Los Angeles, 1973. With Damon Bingham.

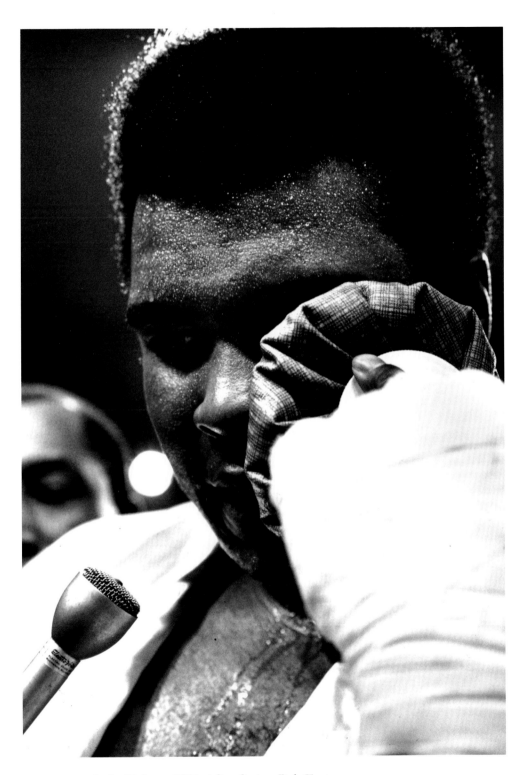

Lake Tahoe, 1972. After facing Bob Foster.

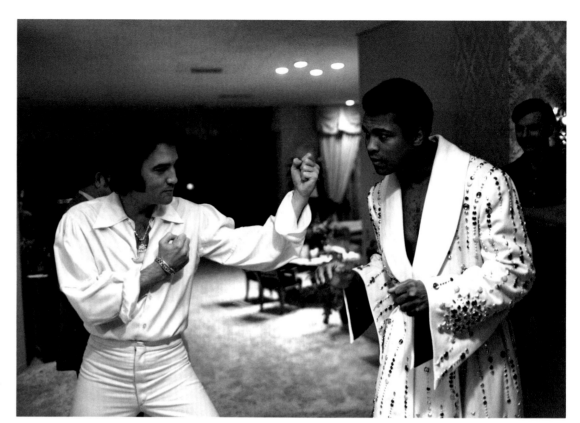

Las Vegas, 1973.
With Elvis Presley,
wearing the robe
Elvis gave him.

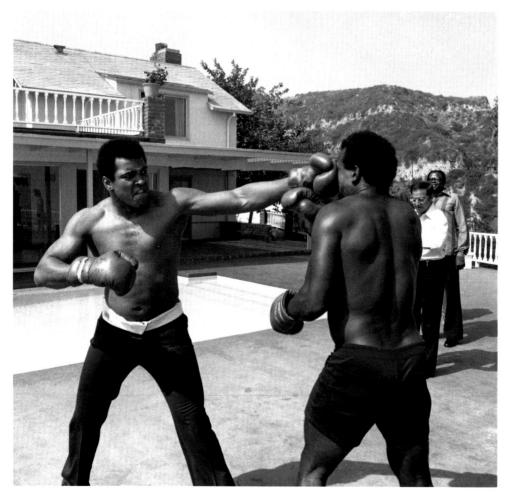

Los Angeles, 1973.
Getting in Jim Brown's
face.

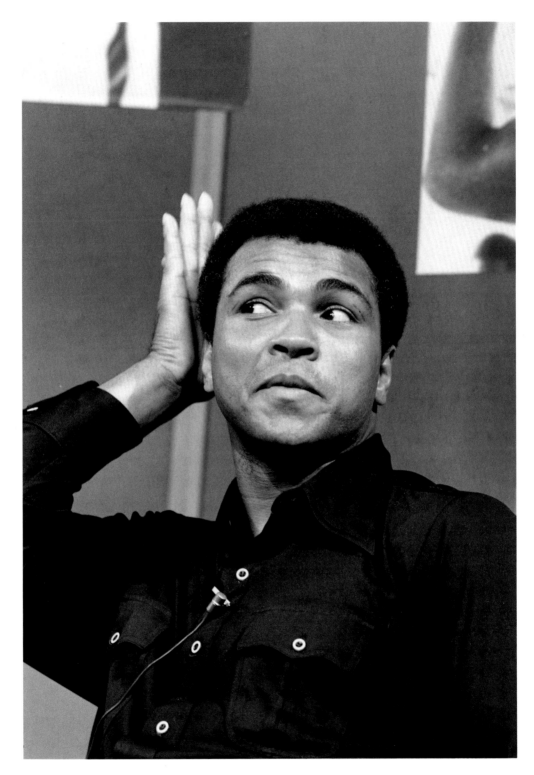

Los Angeles, 1973. Looking pretty.

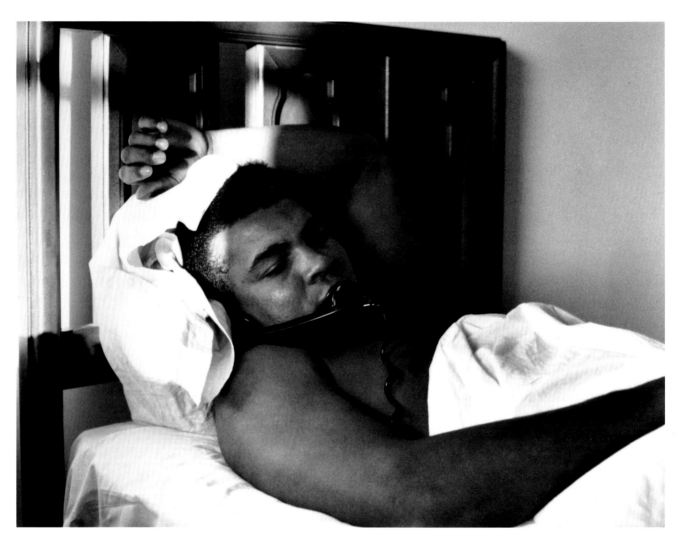

New York, 1974.

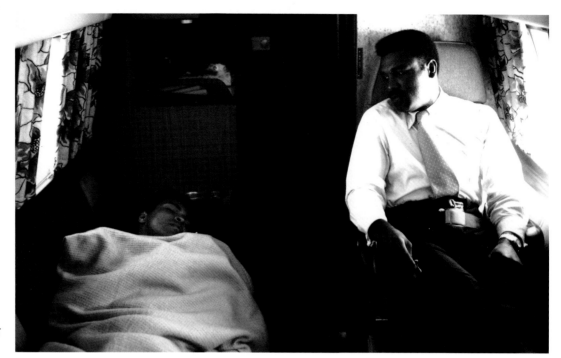

In flight, 1974.
Sleeping, as his brother
watches.

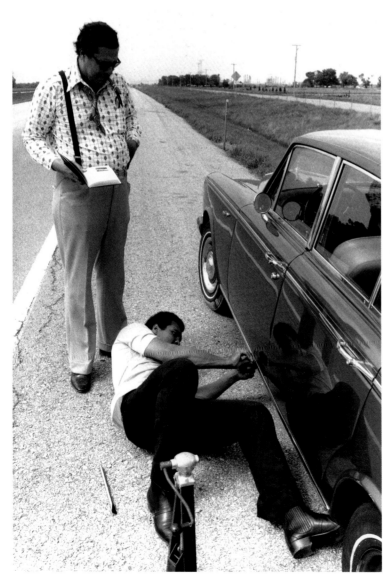

Outside Lake Forest, Illinois, 1974.
Getting his hands dirty.

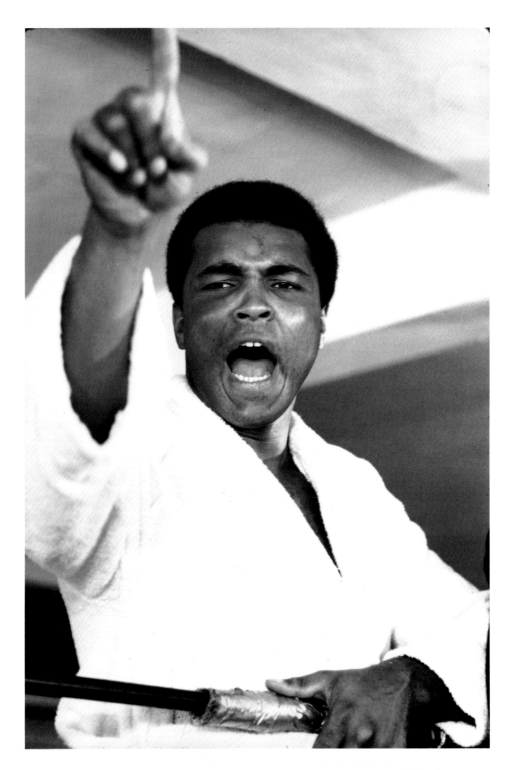

New York, 1974.

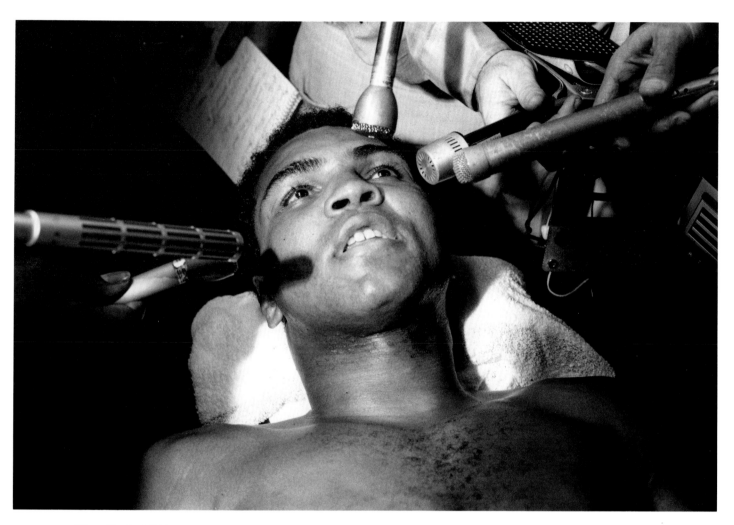

New York, 1974.

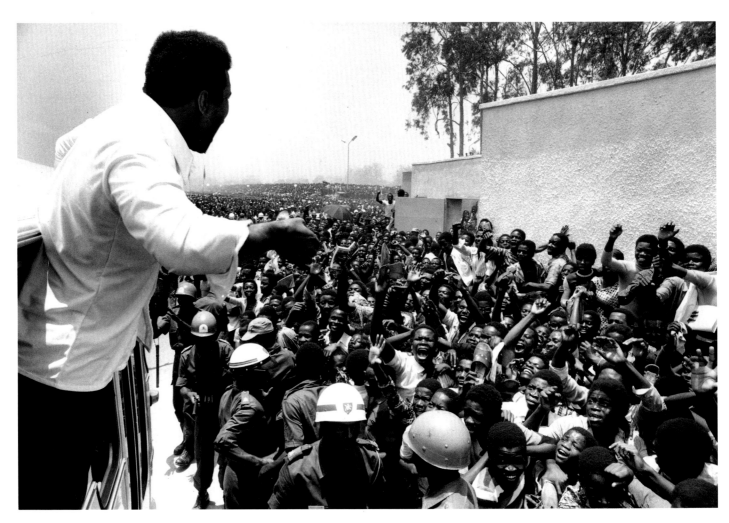

Zaire, 1974.

Zaire, 1974.

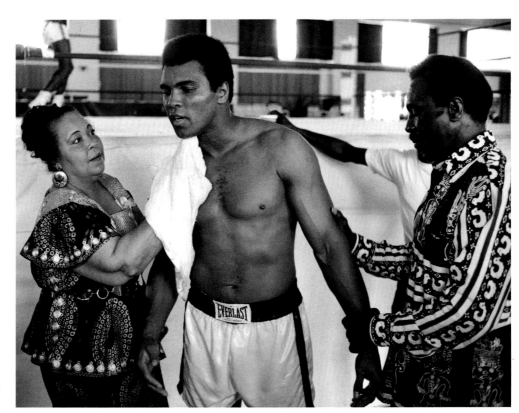

Zaire, 1974. With his
parents, Cassius Clay, Sr.,
and Odessa Clay.

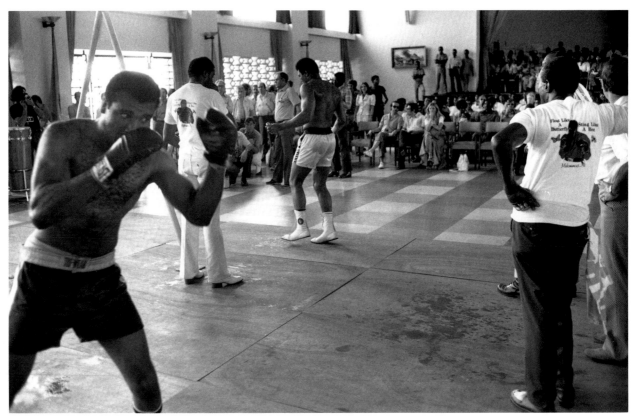

Zaire, 1974. Training, while his brother, Rahaman, shadow boxes
in the foreground.

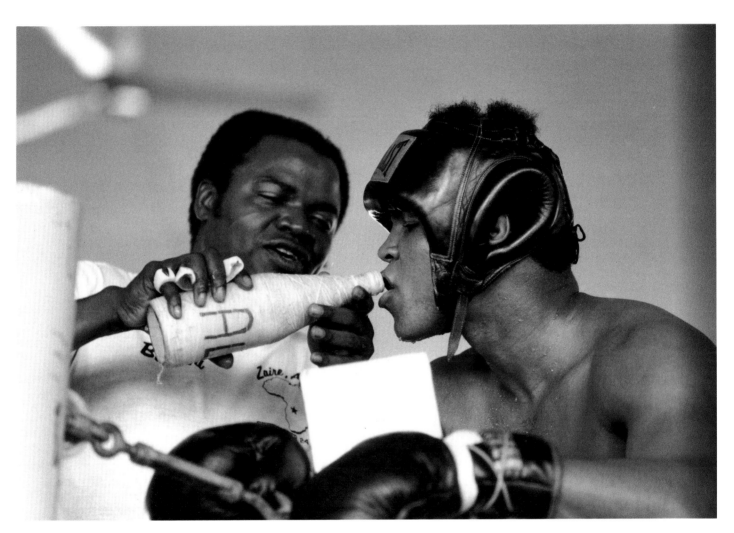

Zaire, 1974. With Drew Bundini Brown.

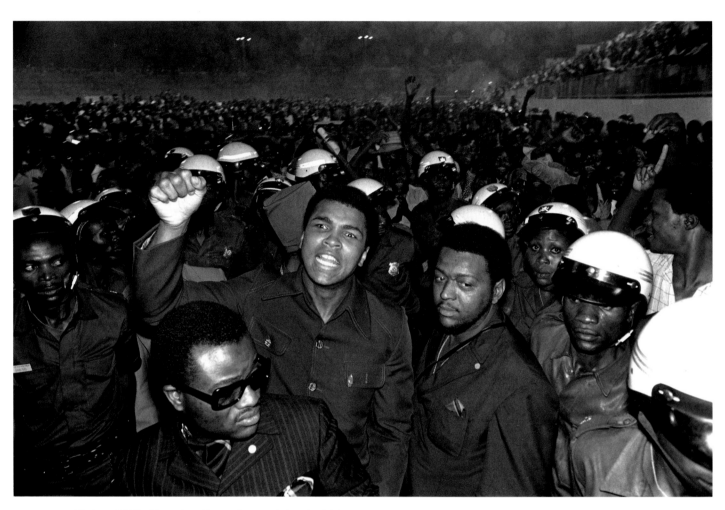

Zaire, 1974. Greeting fans after arriving in Zaire.

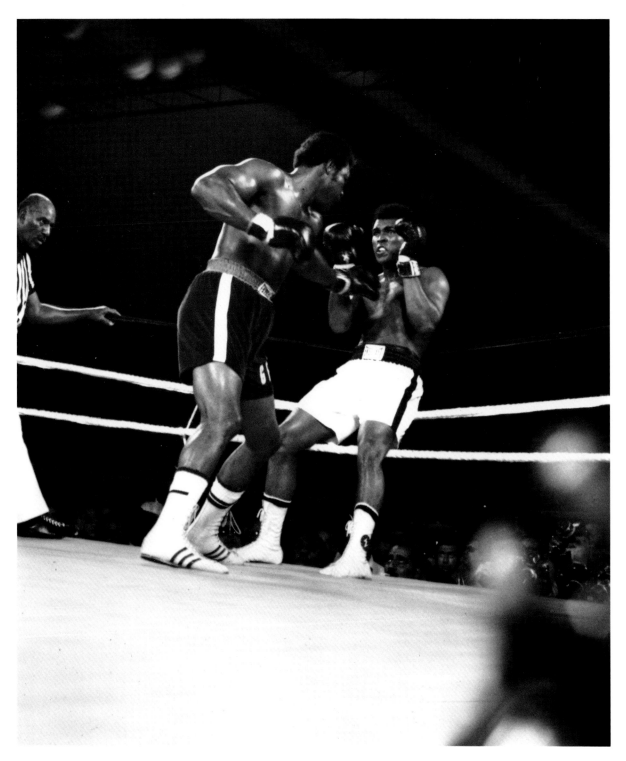

Zaire, 1974. Rope-a-doping against George Foreman.

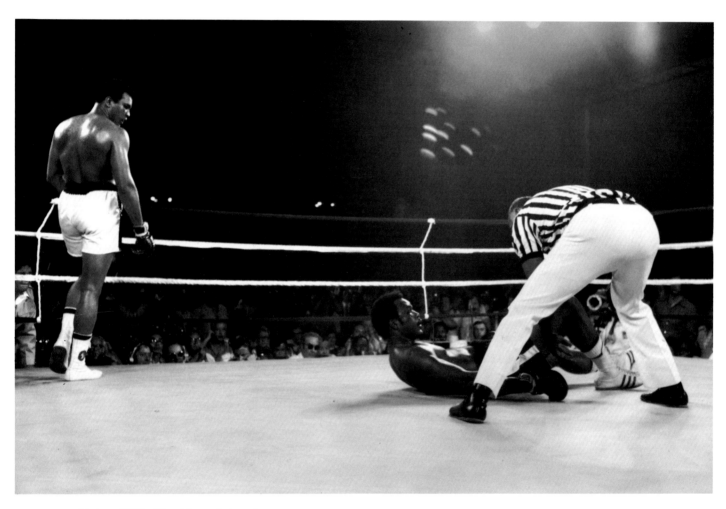

Zaire, 1974. His title reclaimed.

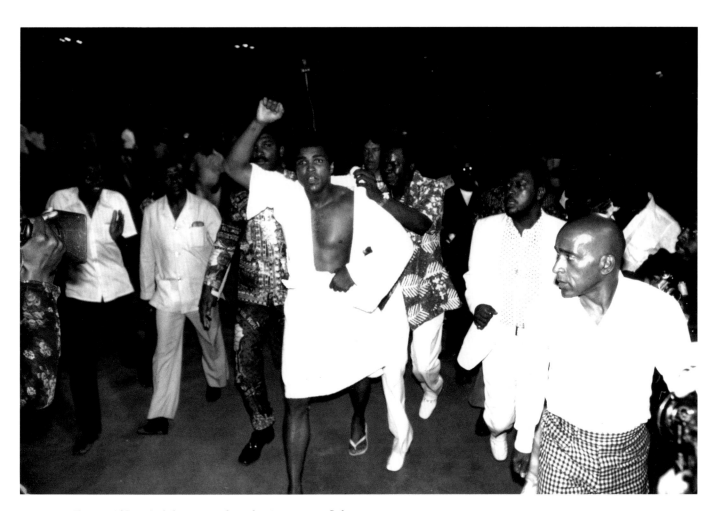

Zaire, 1974. Celebrating after the Foreman fight.

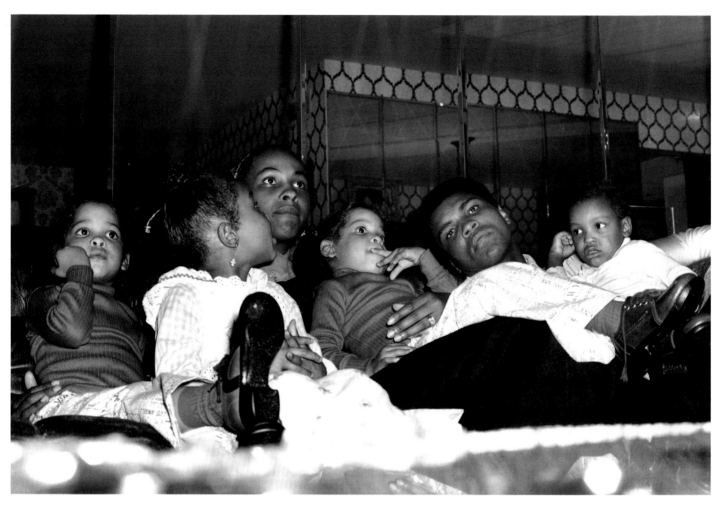

Flossmor, Illinois, 1974. With his family.

Zaire, 1974.

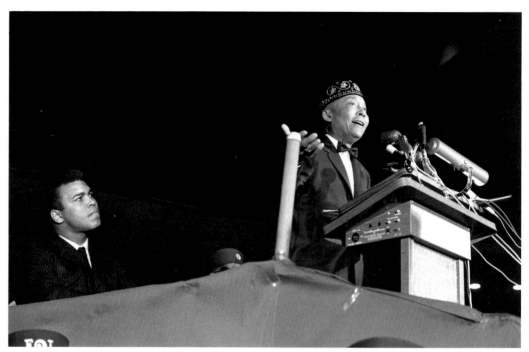

Chicago, 1975. Listening to Elijah Muhammad at the podium.

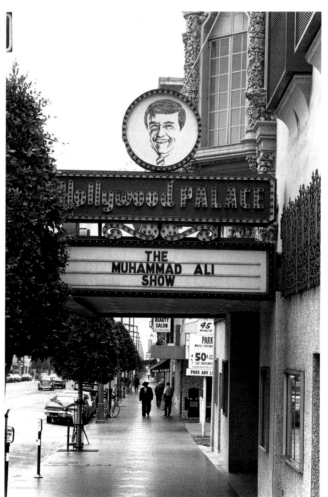

Hollywood, 1975.

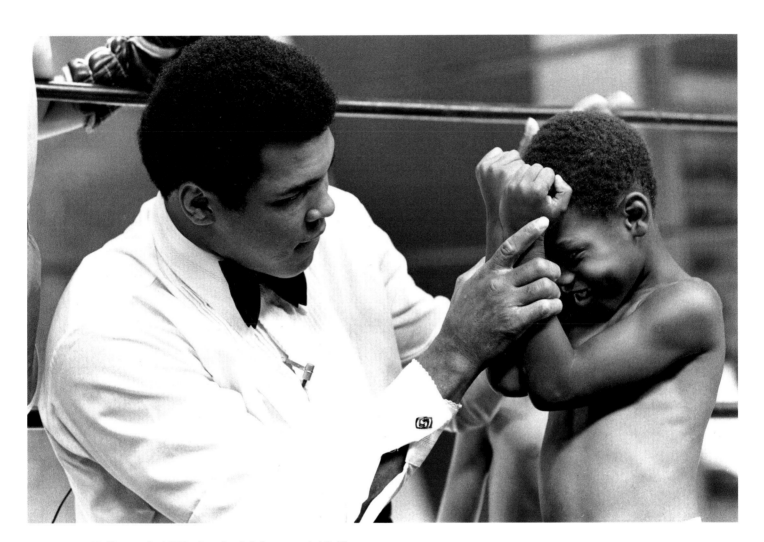

Hollywood, 1975. On the Muhammad Ali Show.

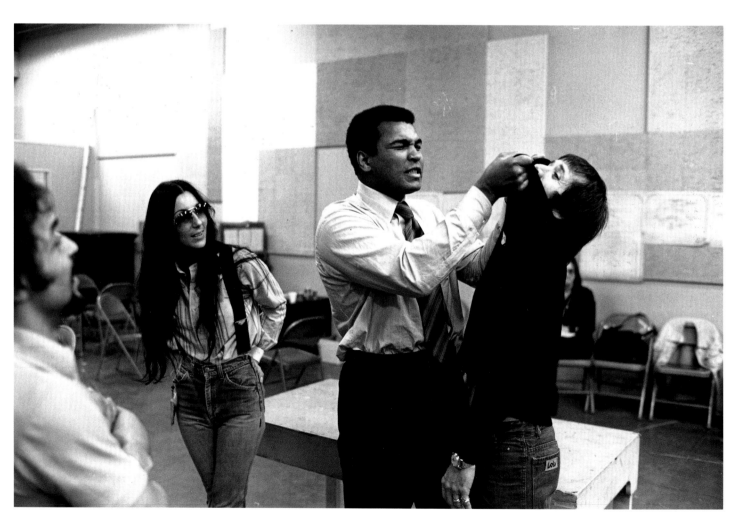

Los Angeles, 1975. With Sonny and Cher.

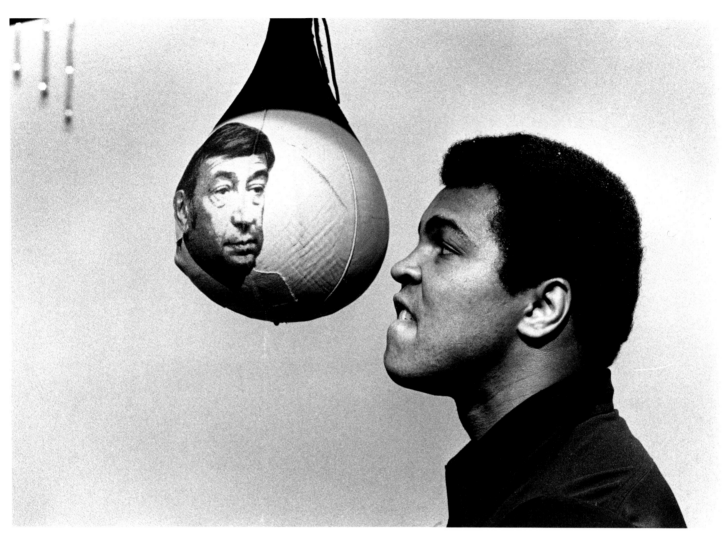

Hollywood, 1975. During rehearsals for "The Muhammad Ali Show."

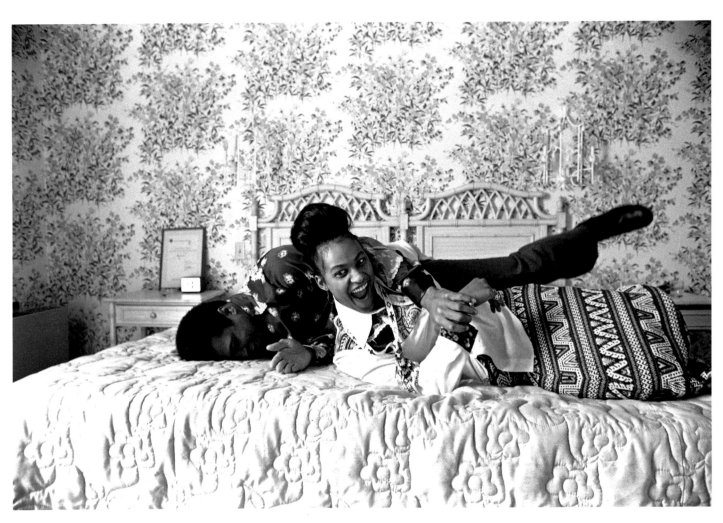

Cleveland, 1975. With his wife, Belinda Ali.

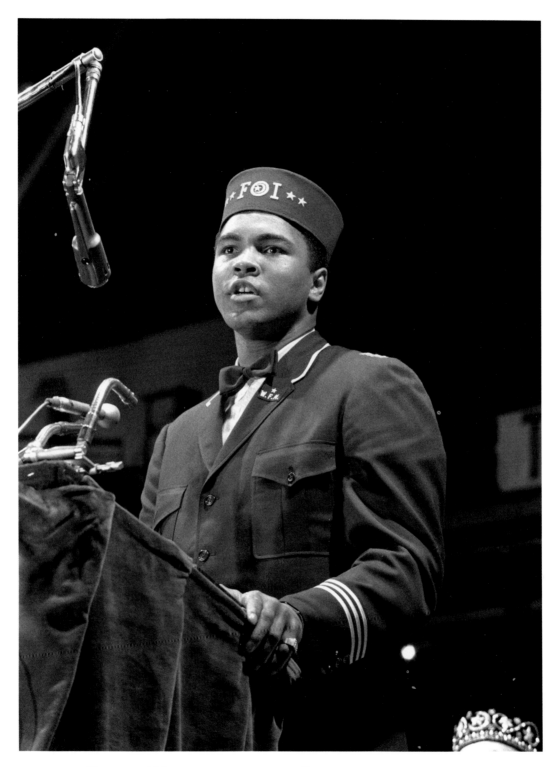

Chicago, 1975.

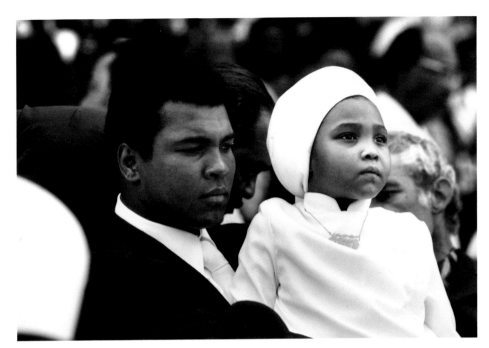

Jamaica, 1975. With his daughter, Maryum.

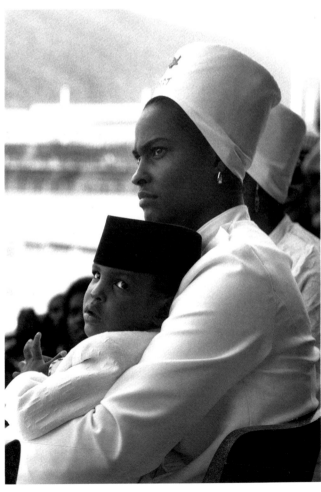

Jamaica, 1975. Belinda Ali and Muhammad Ali, Jr.

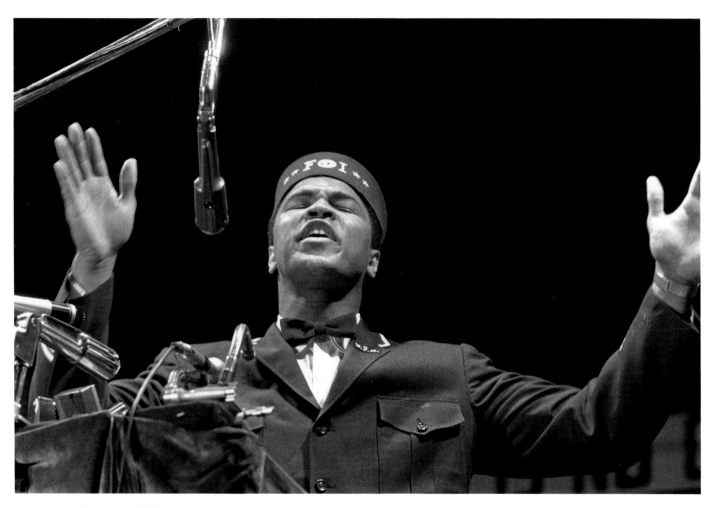

Chicago, 1975.

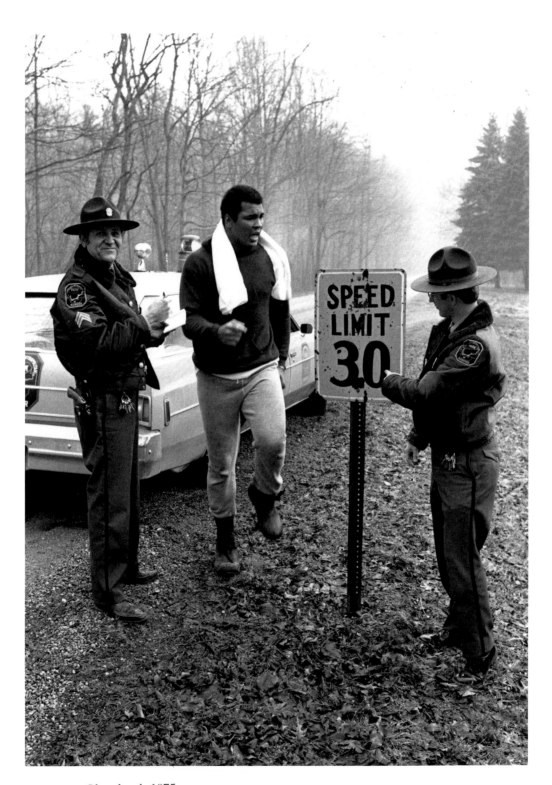

Cleveland, 1975.

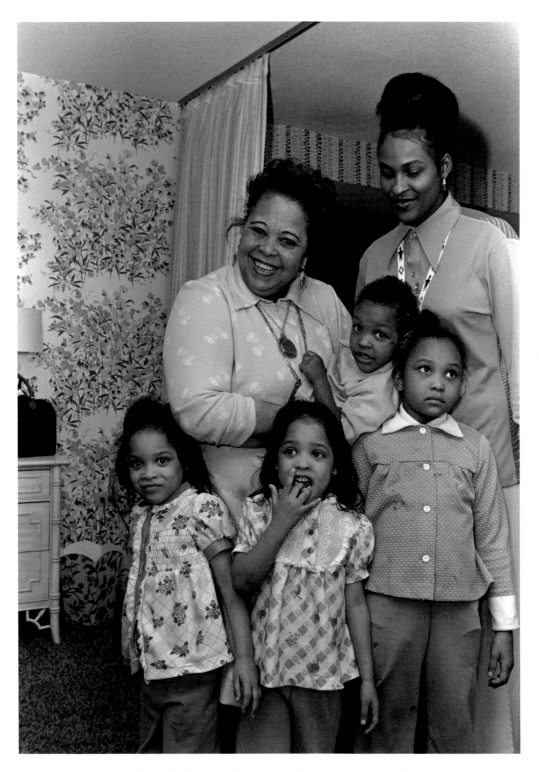

Cleveland, 1975. Odessa Clay, Belinda Ali, and her children,
Jamilliah, Rasheeda, Maryum, and Muhammad, Jr.

Cambridge, Massachusetts, 1975. With his second wife, Belinda
Ali *(center)*, and his future wives.Veronica Porche *(right)*, and
Lonnie Williams *(left)*.

Los Angeles, 1976.

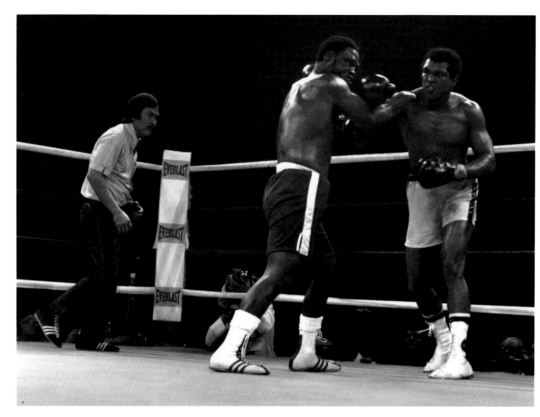

Manila, 1975. Fighting
Joe Frazier.

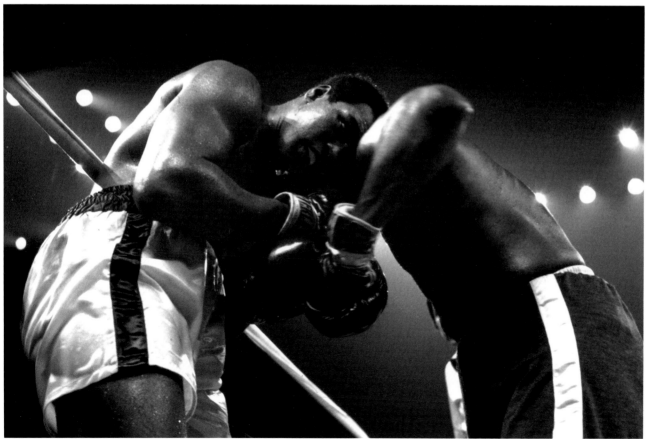

Manila, 1975. Fighting Frazier off the ropes.

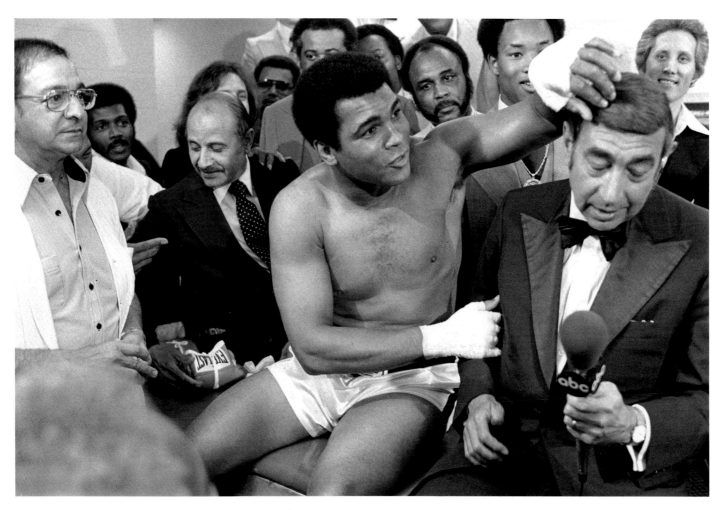

New York, 1976. Pestering Howard Cosell.

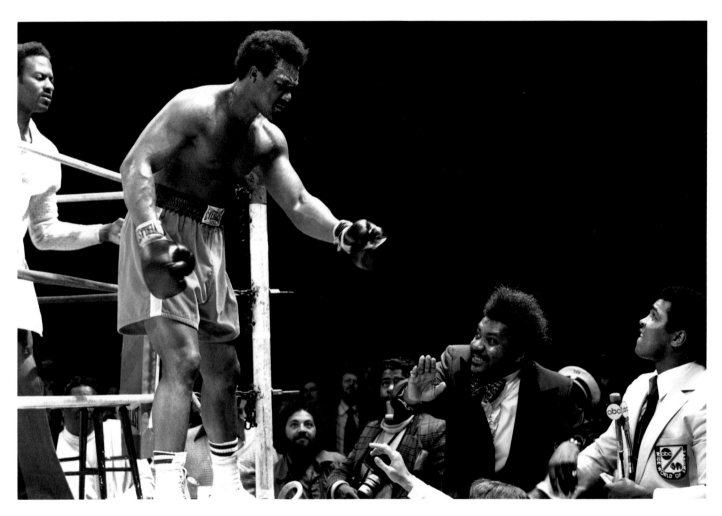

Toronto, 1975. Taunting George Foreman, while Don King tries
to intervene, on the night Foreman fought five men.

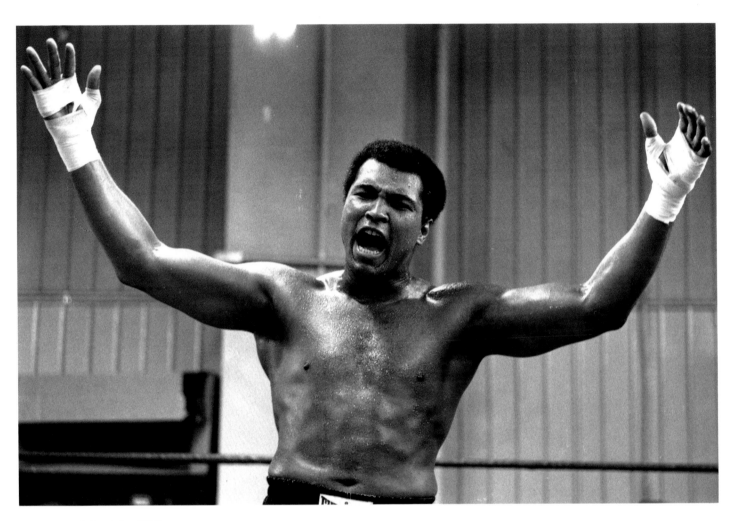

Munich, 1976.

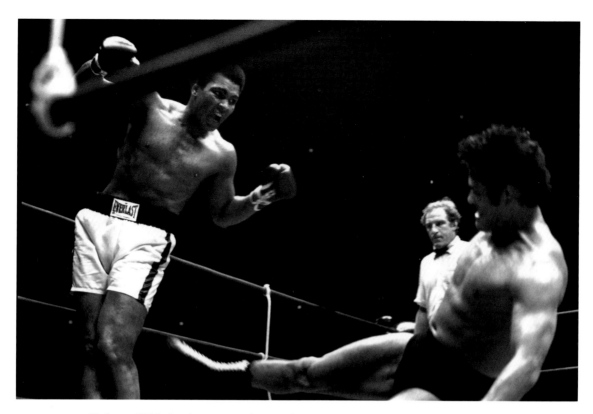

Tokyo, 1976. In the ring with wrestler Antonio Inoki.

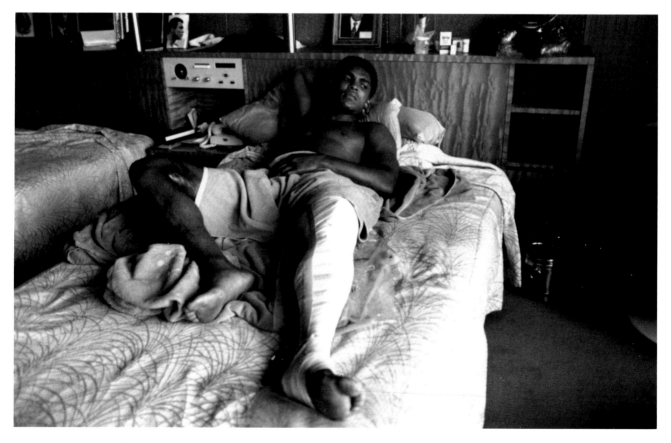

Tokyo, 1976. Recovering from blood clots resulting from his match with Inoki.

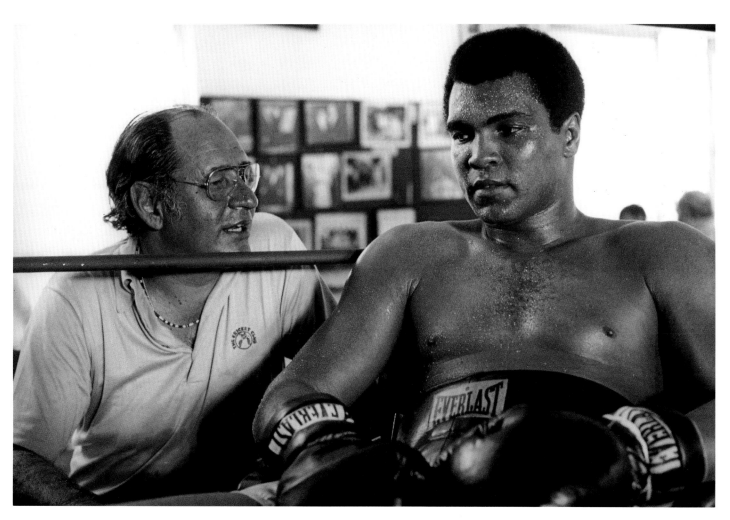

New York, 1976. With Ferdie Pacheco.

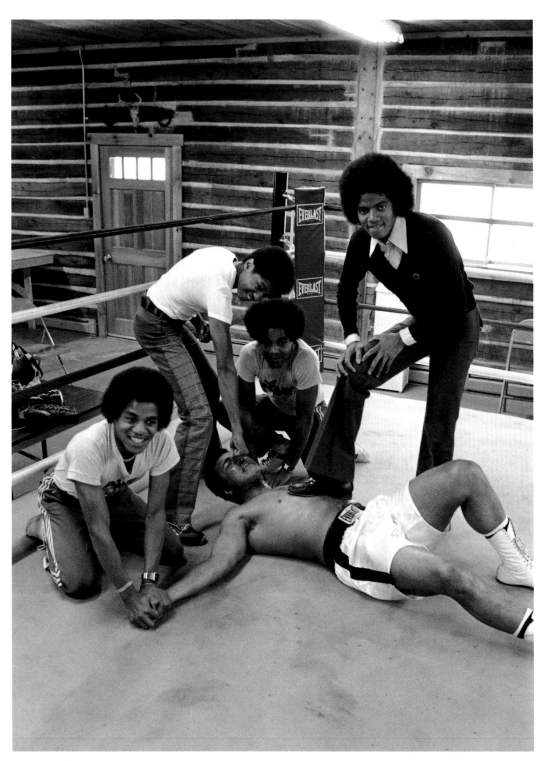

Deer Lake, 1977. With the Jacksons.

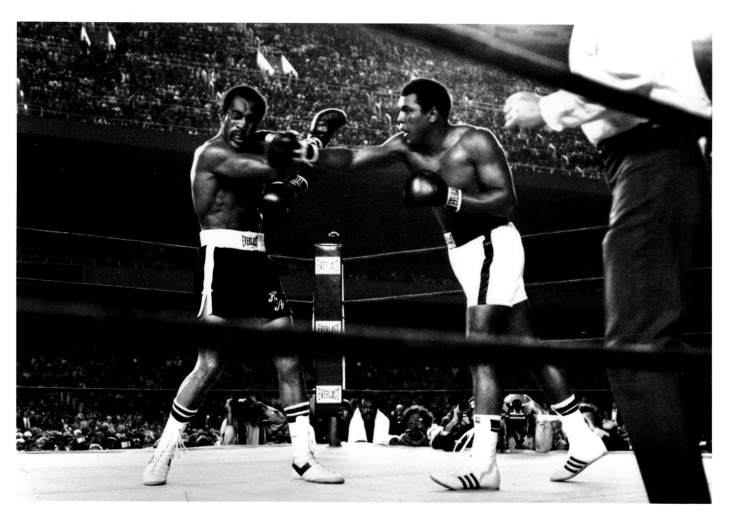

New York, 1976. Fighting Ken Norton at Yankee Stadium.

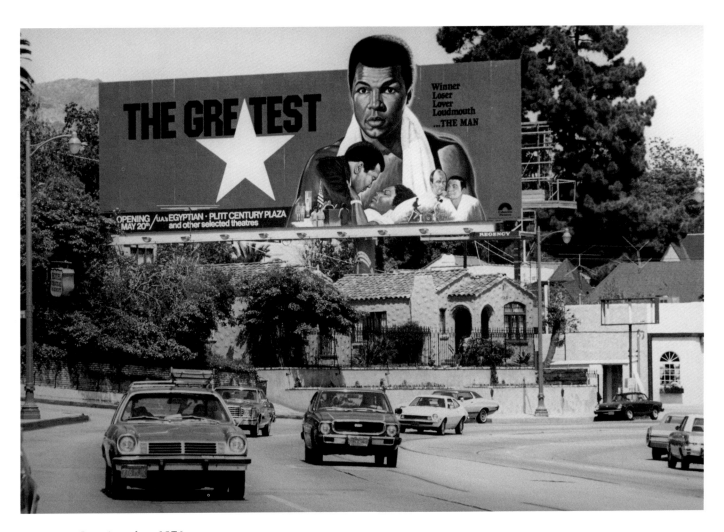

Los Angeles, 1976.

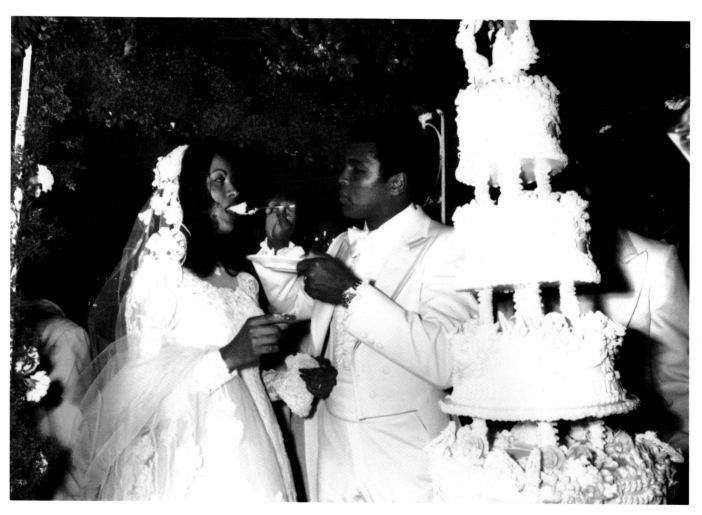

Los Angeles, 1976. With his third wife, Veronica Ali.

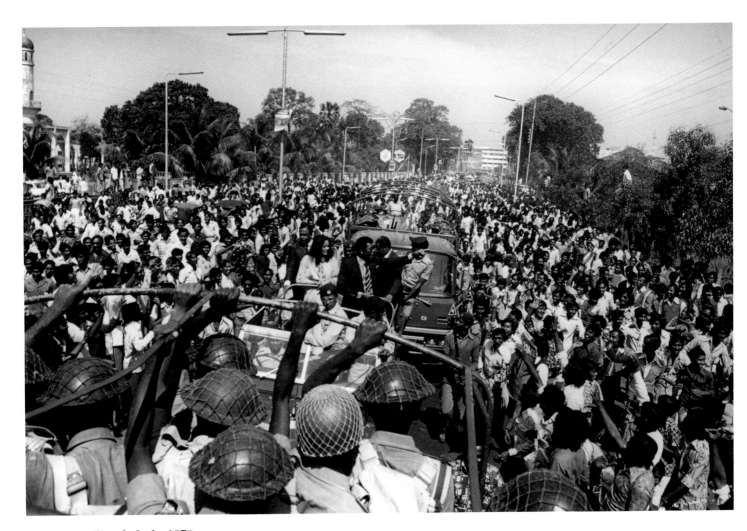

Bangladesh, 1978.

Deer Lake, 1978. Trainer Luis Sarria.

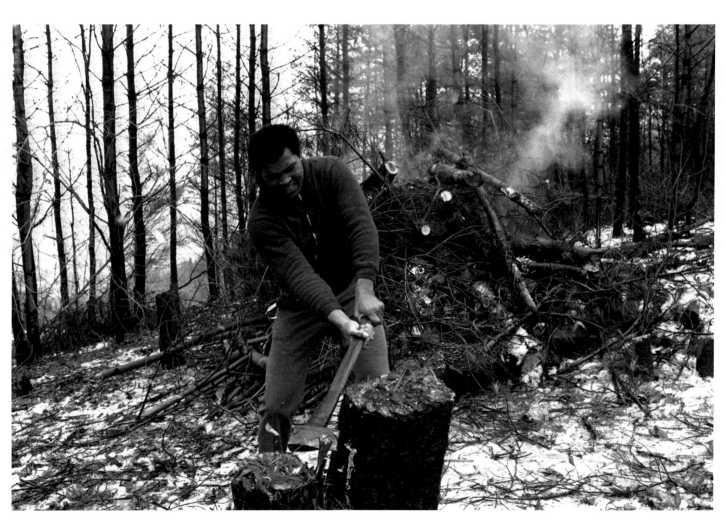

Deer Lake, 1978.

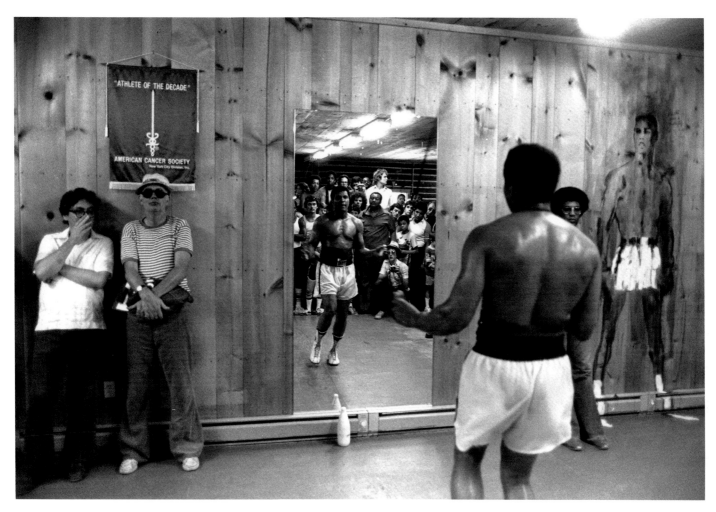

Deer Lake, 1978.

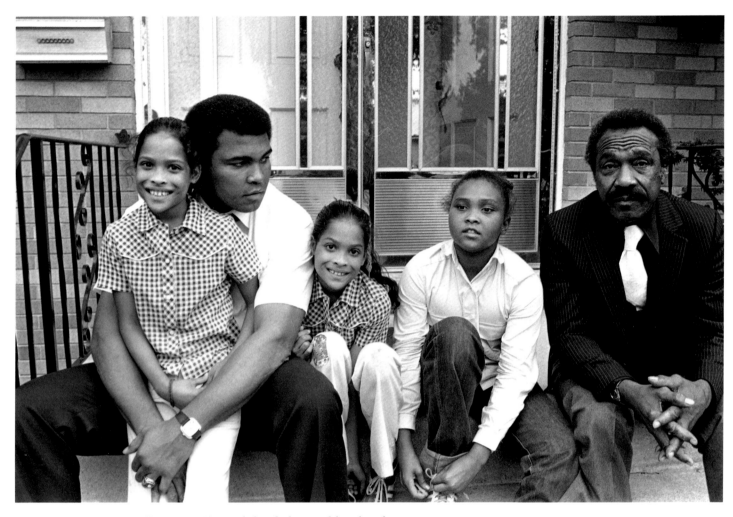

Flossmor, Illinois, 1979. With his father and his daughters,
Rasheeda, Jamillah, and Maryum.

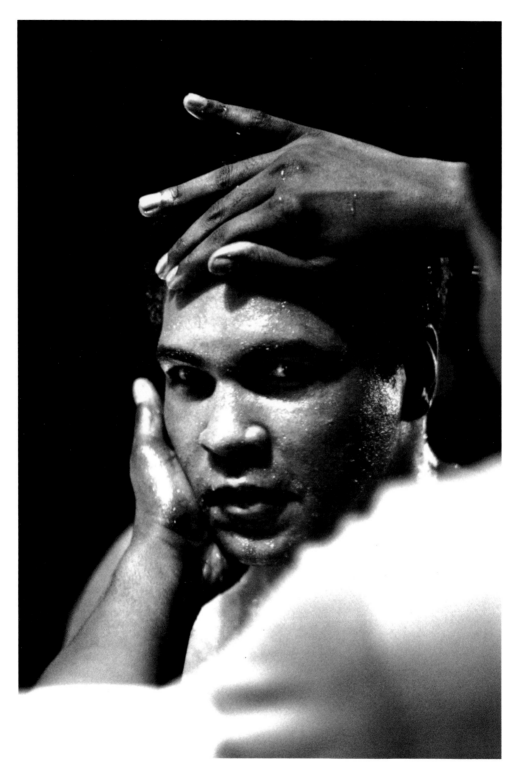

Deer Lake, 1978.

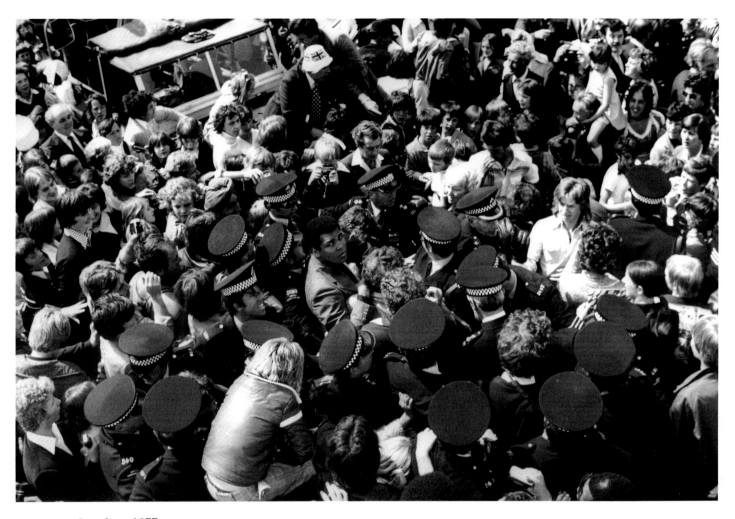

London, 1977.

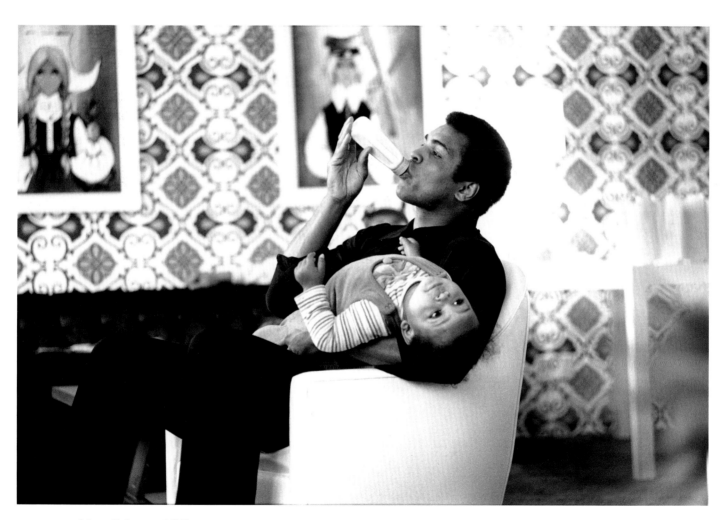

New Orleans, 1978.

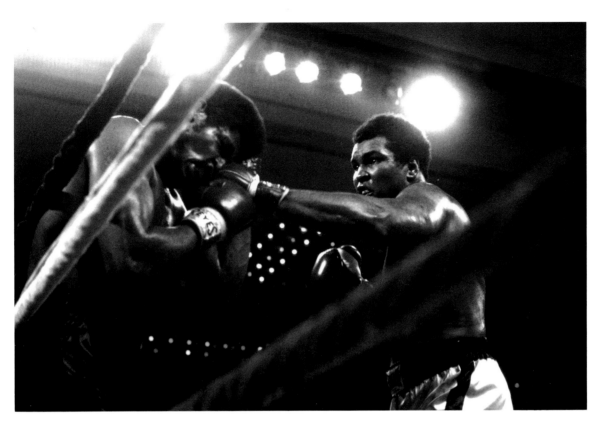

Las Vegas, 1978. Fighting Leon Spinks.

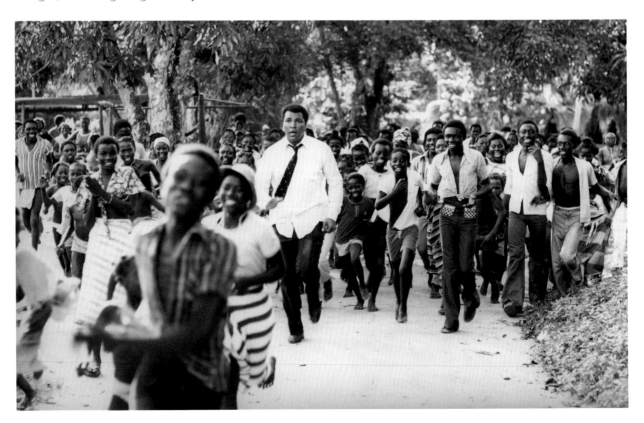

Curaçao, 1979.

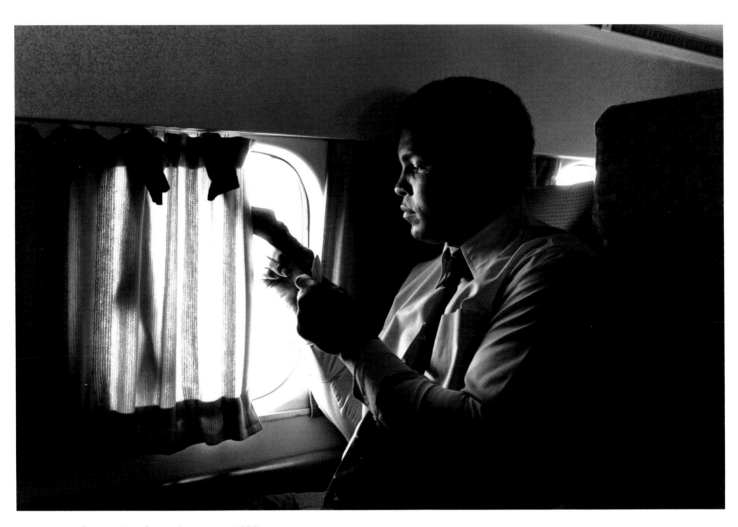

Returning from Curaçao, 1979.

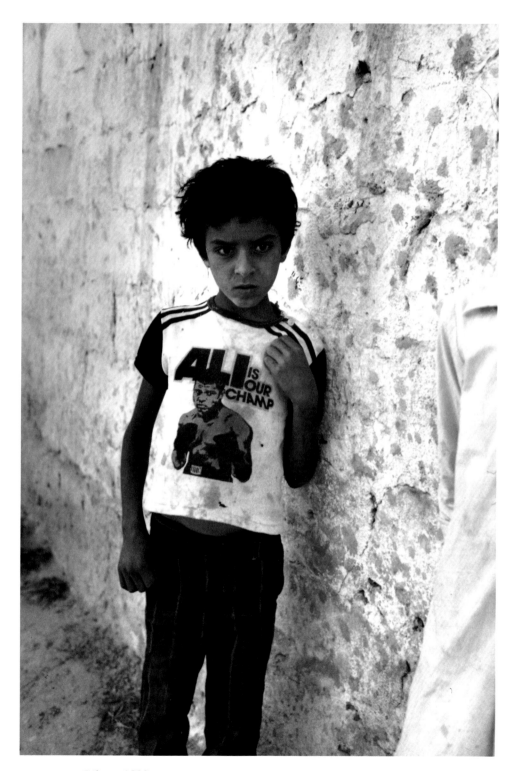

Libya, 1980.

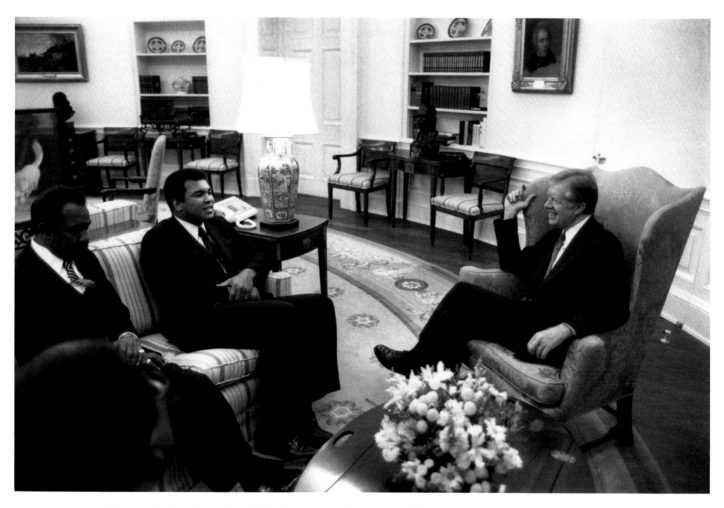

Washington, D.C., 1980. With his father, visiting Jimmy Carter at the White House.

Deer Lake, 1980.

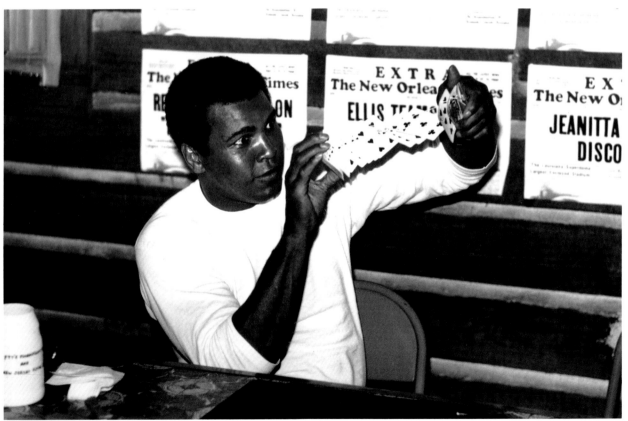

Deer Lake, 1981.

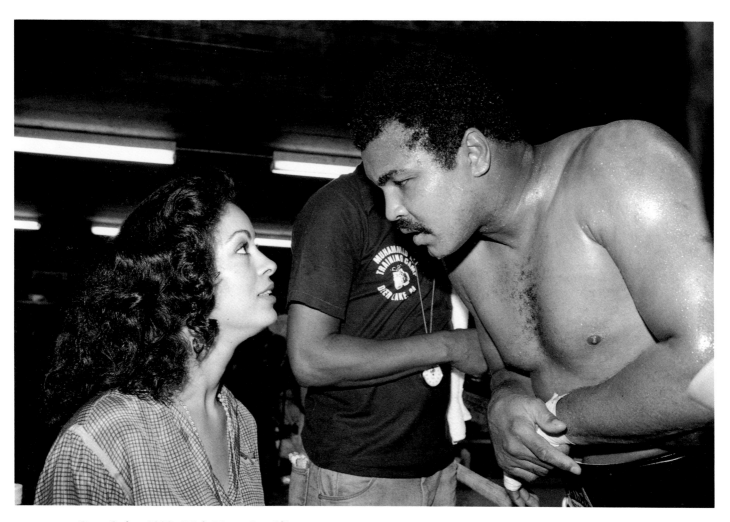

Deer Lake, 1980. With Veronica Ali.

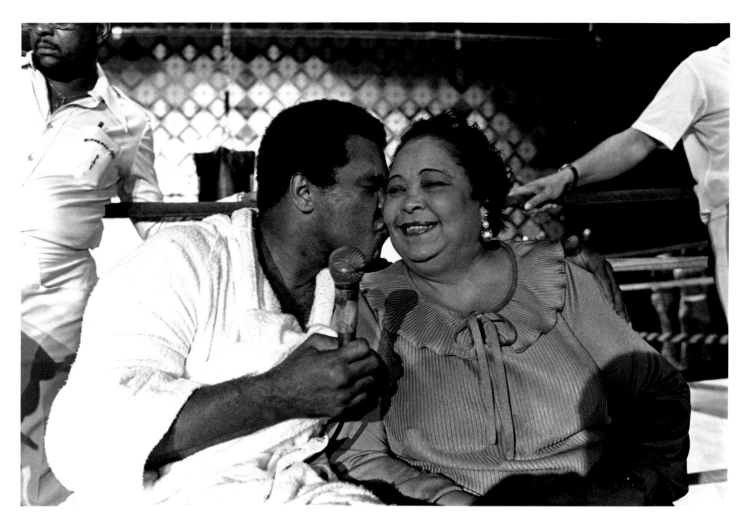

Bahamas, 1981. With his mother.

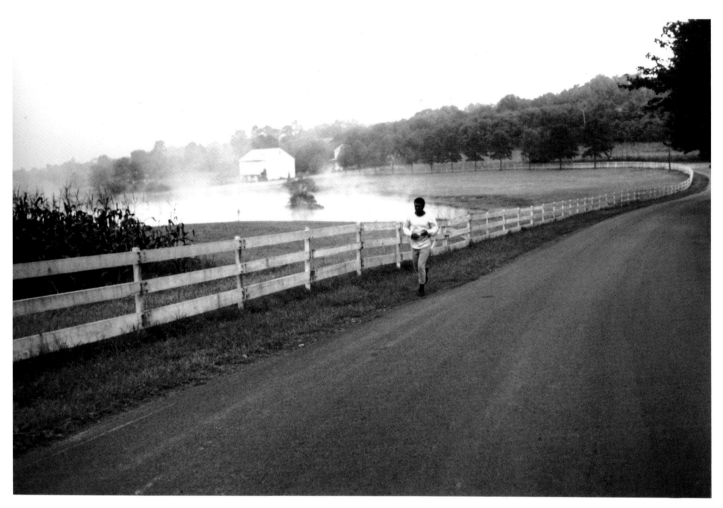

Deer Lake, 1980.

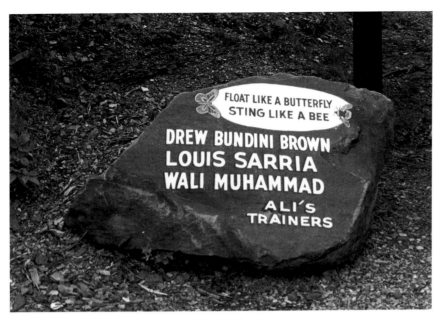

Deer Lake, 1991.

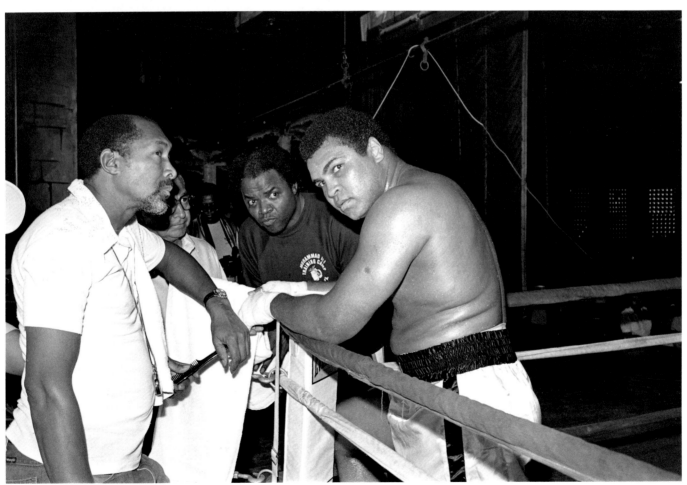

Bahamas, 1981. With his cornermen Wali "Blood" Muhammad,
Angelo Dundee, and Drew Bundini Brown.

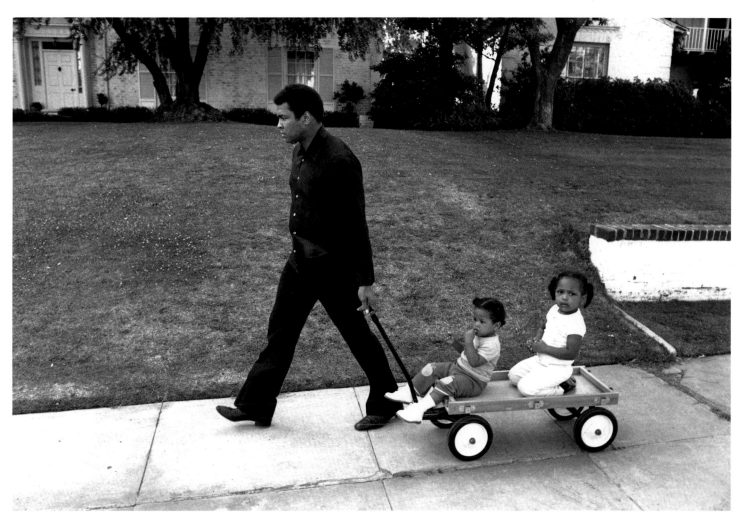

Los Angeles, 1981.

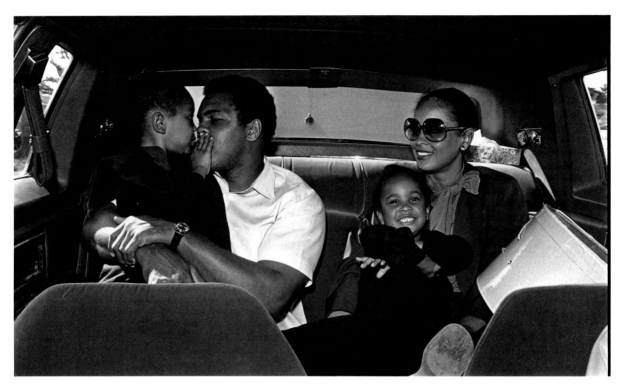

Bahamas, 1981. With Veronica Ali, and their daughters, Hana and Laila.

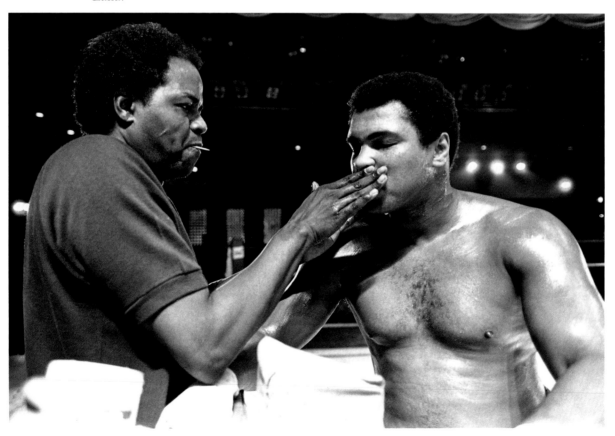

Bahamas, 1981. With Bundini Brown.

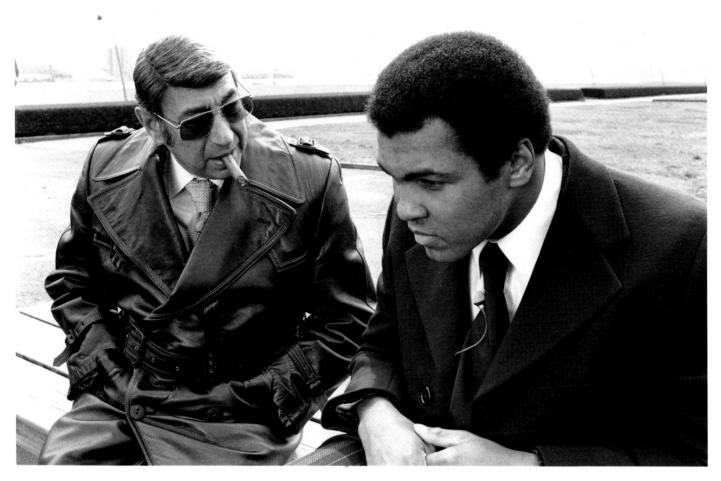

New York, 1981. With Howard Cosell.

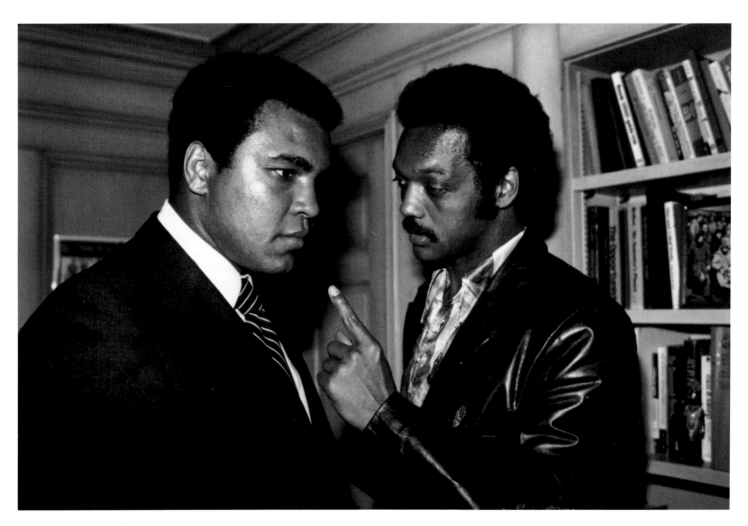

New York, 1983. With Jesse Jackson.

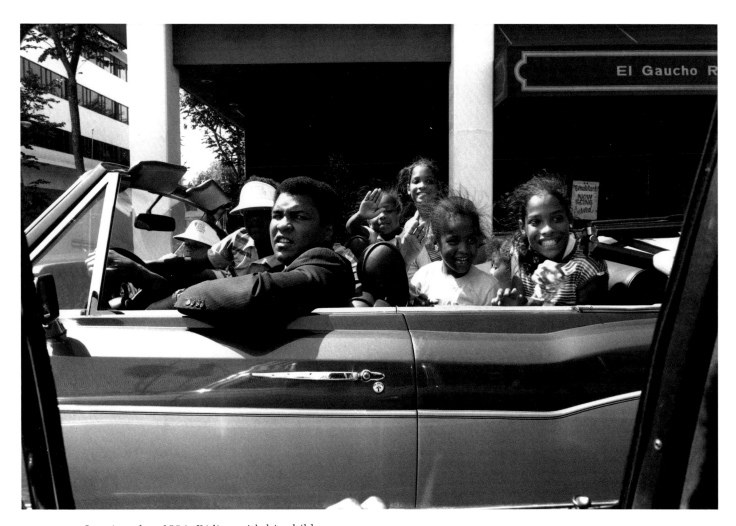

Los Angeles, 1984. Riding with his children.

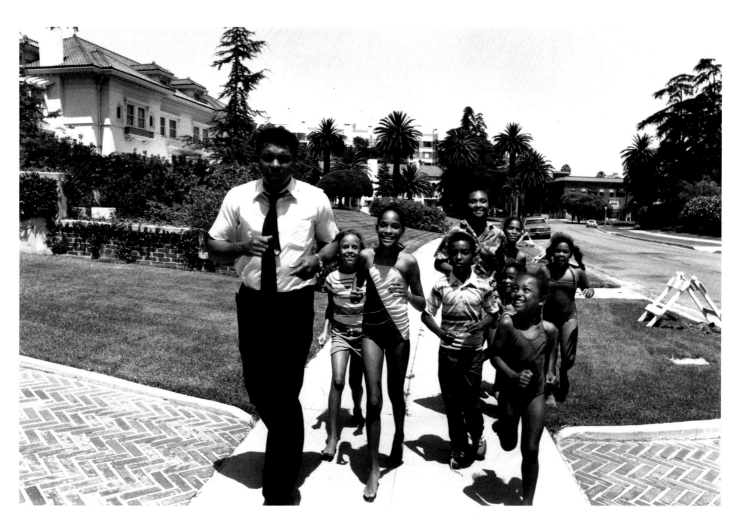

Los Angeles, 1984. With his children.

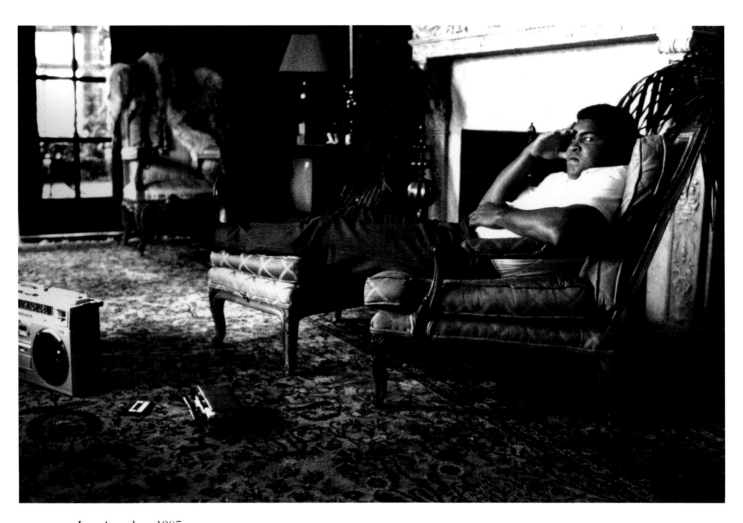

Los Angeles, 1985.

Los Angeles, 1988. With Sugar Ray Robinson shortly before his death.

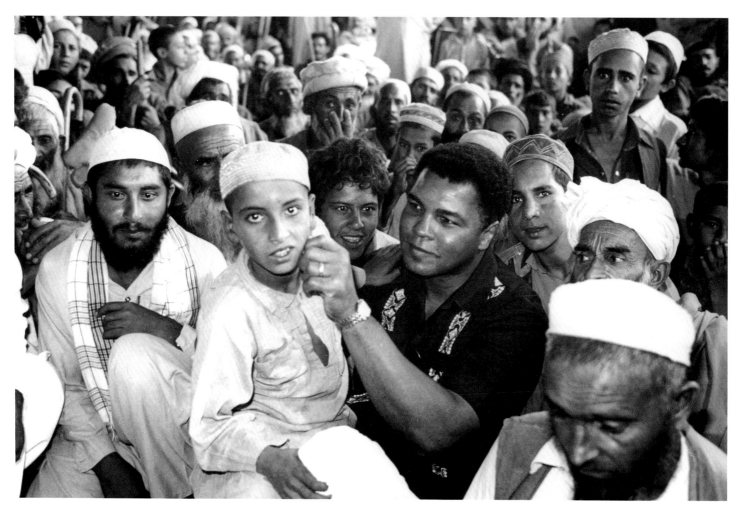

Pakistan, 1988. Visiting refugees from Afghanistan.

New York, 1967. Transcribing quotations from the Quar'an.

Los Angeles, 1989. Autographing Muslim pamphlets.

Chicago, 1989. Picking up Muslim pamphlets to autograph.

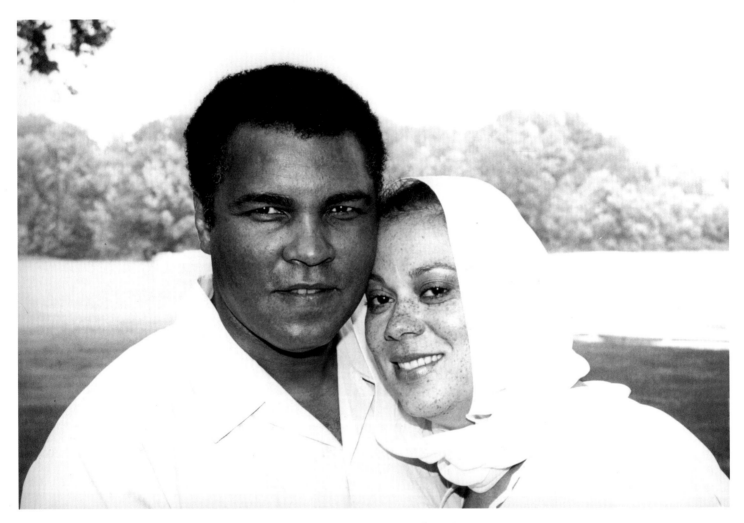

Berrien Springs, Michigan, 1989. With his wife, Lonnie, at their home.

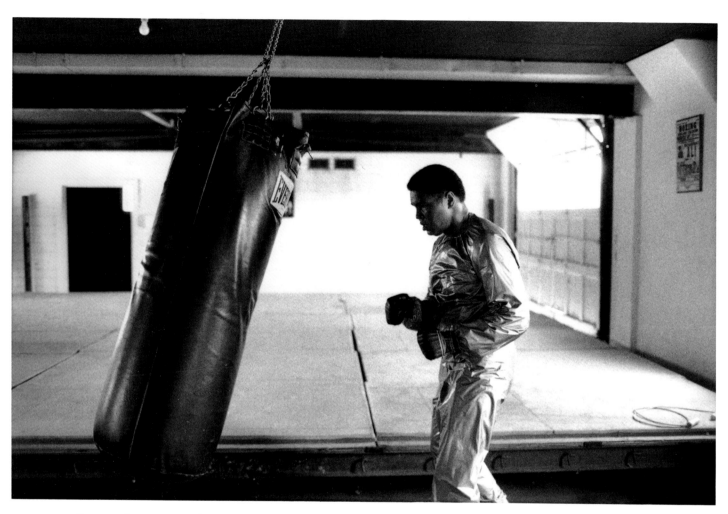

Berrien Springs, Michigan, 1990.

New York, 1989.

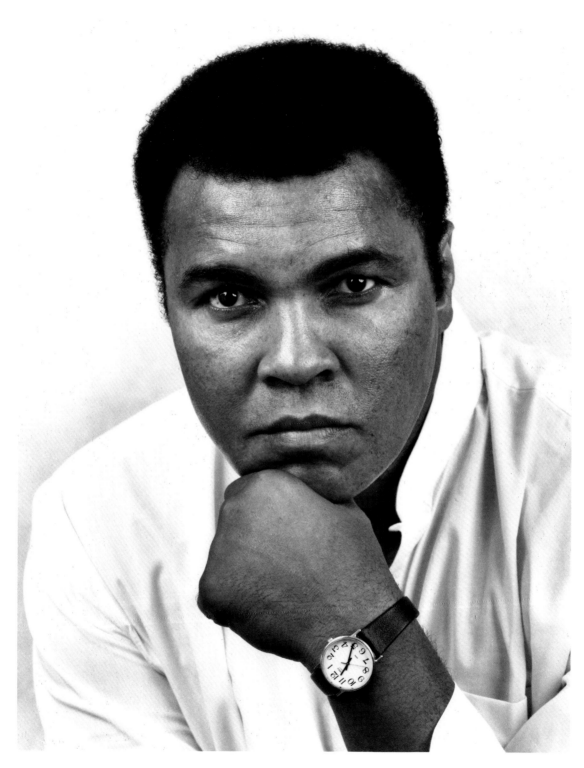

Los Angeles, 1990.

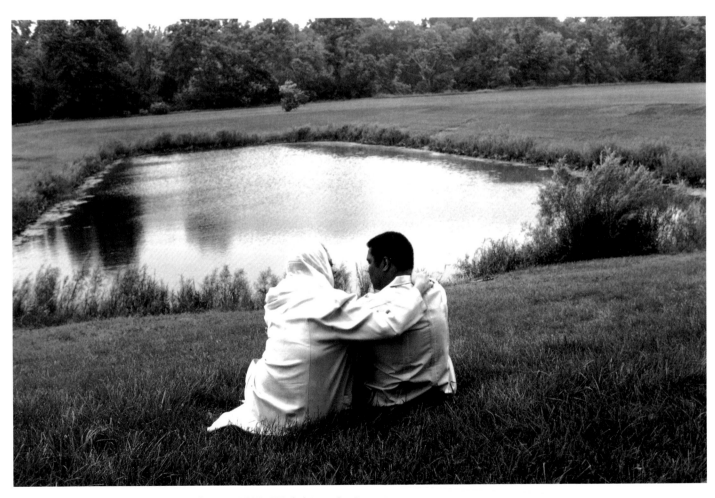

Berrien Springs, Michigan, 1989. With his wife, Lonnie.

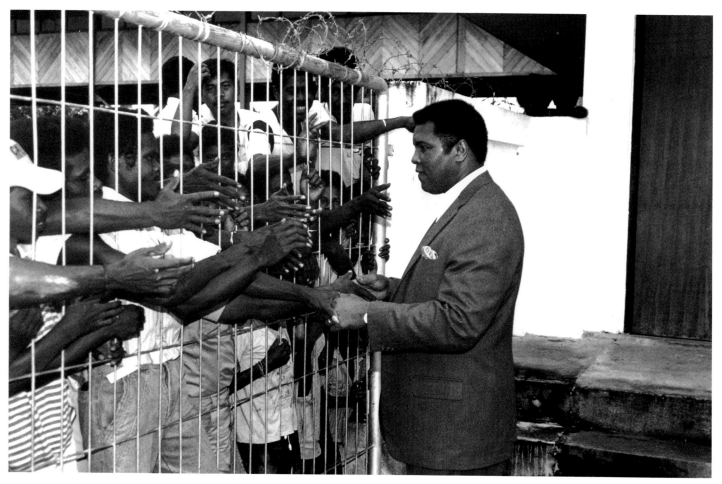

Indonesia, 1990.

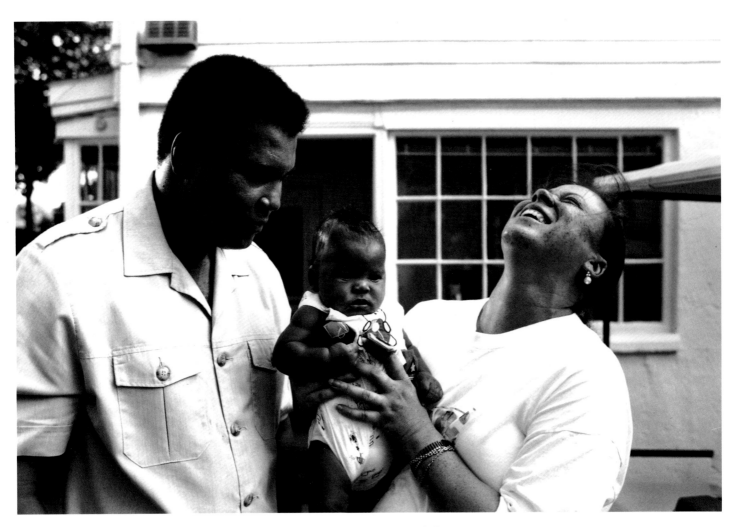

Berrien Springs, Michigan, 1991. With his wife, Lonnie, and their son, Asaad.

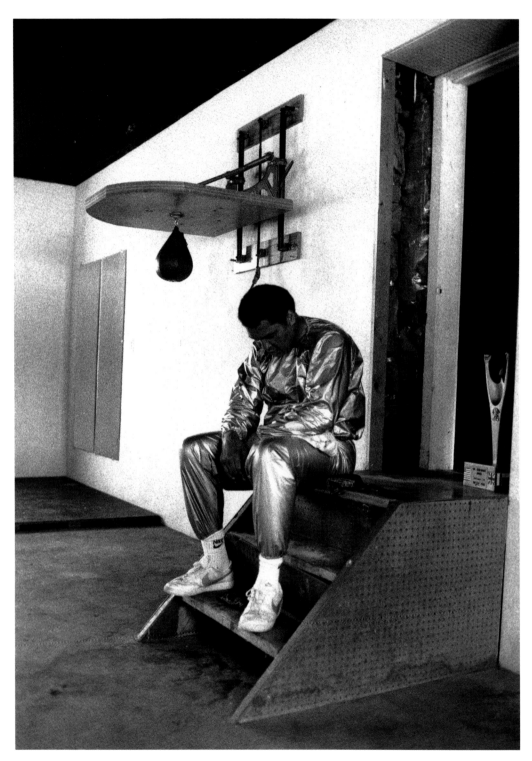

Berrien Springs, Michigan, 1990.

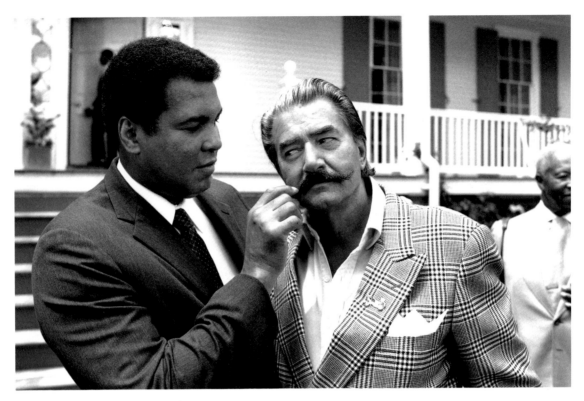

New York, 1991. With Leroy Neiman.

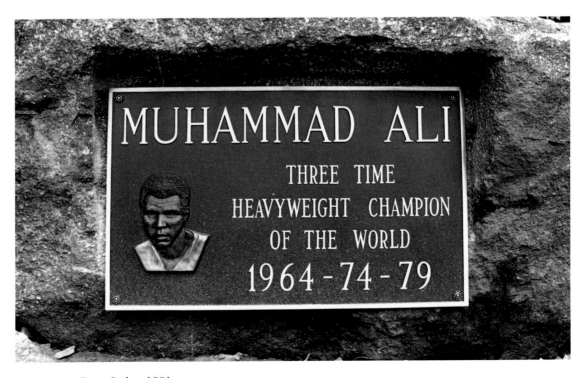

Deer Lake, 1991.

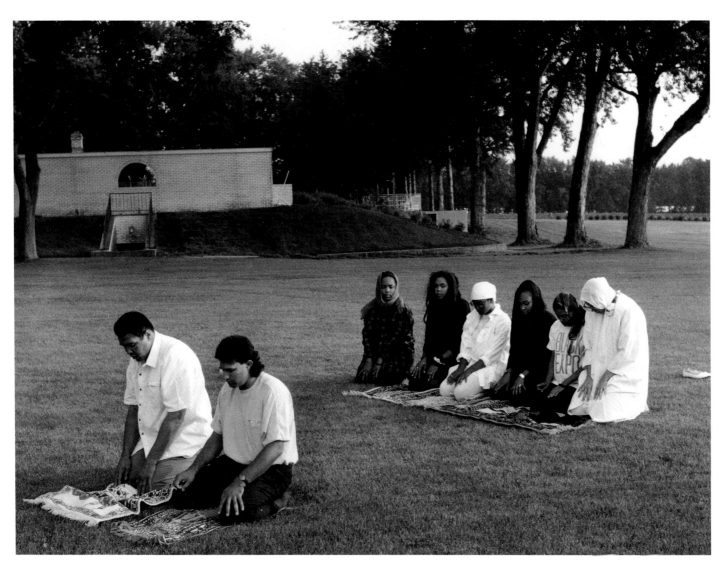

Deer Lake, 1990. At prayer with his family and guests.

Deer Lake, 1991.

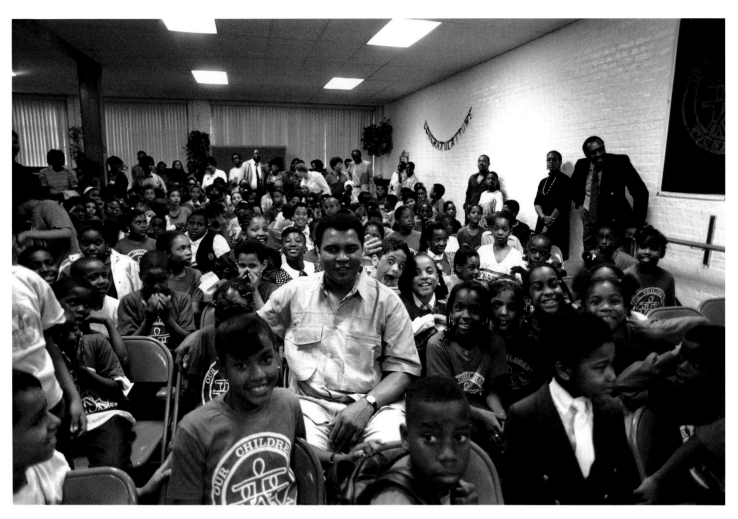

New York, 1991. Visiting the Save Our Children Foundation.

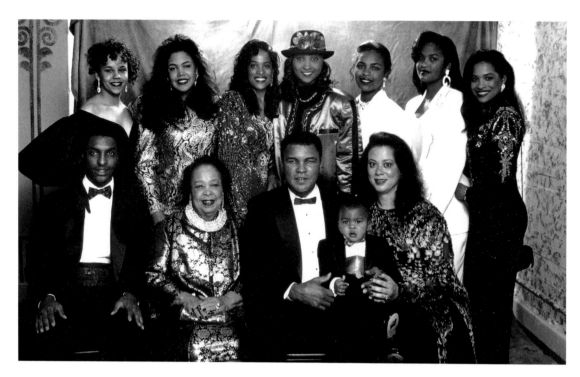

Los Angeles, 1992. Muhammad Ali and his family at his fiftieth birthday celebration. *(Front, left to right)* Muhammad, Jr., Odessa Clay, Muhammad, Asaad, Lonnie; *(back, left to right)* Miya, Khaliah, Rasheeda, Maryum, Hana, Laila, Jamilliah.

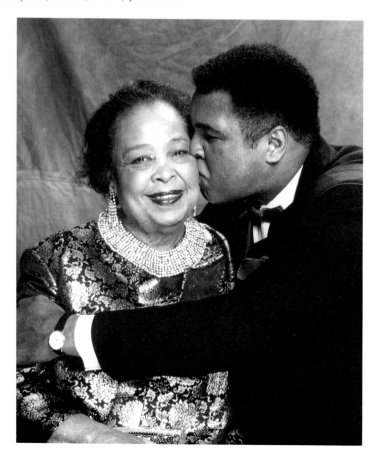

Los Angeles, 1992. With his mother.

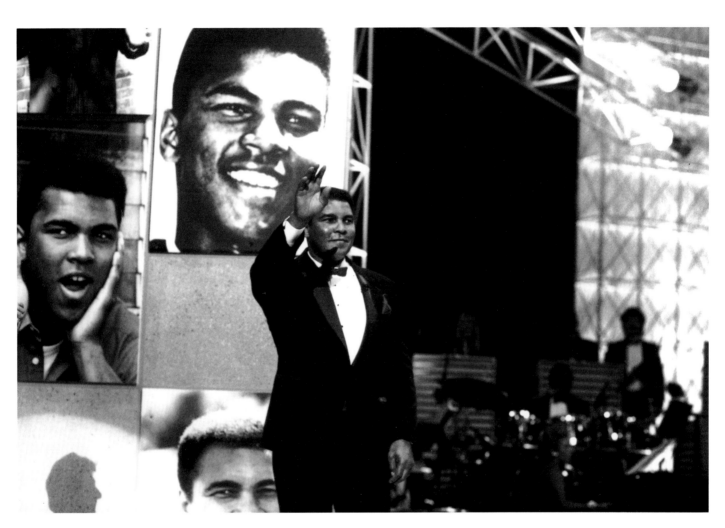

Los Angeles, 1992.

# Afterword
Howard L. Bingham

A photographer's best work, like that of a writer, is shaped by his life experience. My people come from Jackson, Mississippi. I am the son of a minister and a minister's wife. They were proper, resilient, and loving people. They did the best they could with what they had for their children. However, nothing in my parents' life experience would prepare us children for what we would confront in the world.

My real lessons in life began on the wide, endless avenues of South Central Los Angeles. I grew to manhood during a time when a generation of African Americans were, in the words of Dr. King, "straightening up their backs." I was one of those young African Americans; so was Muhammad Ali.

I met Muhammad by chance, but our lasting friendship is no accident. I first knew him as Cassius Clay, but shortly thereafter he changed his name to Muhammad Ali and became a card-carrying member of the "Black Muslims." It might have been awkward for most people to deal with the controversy that surrounded such a move, but not Muhammad. Not long after he changed his name, Muhammad was drafted for military service in the Vietnam War. Again, when he refused induction into the army, Muhammad faced a ground swell of resentment and hostility. Only a handful of people openly supported his stance, but I never saw Muhammad falter in his beliefs or question his decision once it was made.

Muhammad was and is one in a million. I have watched for thirty years how he has changed the lives of people he has touched, making old people smile and feel loved, giving them a hug or a kiss on the cheek, showing terminally ill children his magic tricks and making them laugh, taking money from his own pocket to give to the hungry strangers he meets on the street, visiting homeless shelters and street people,

sometimes taking meat from his own freezer down to a soup kitchen because he thought the soup kitchen needed it more than he did, visiting those who are locked away in prison and have lost hope, and standing in hotel lobbies and on sidewalks signing autographs for adoring fans who might not otherwise have the chance to meet him.

I have also watched while some have taken advantage of the innocence and kindness Muhammad offered. I watched this with hurt in my heart, powerless to stop their actions, while Muhammad forgave and opened his arms to these offenders like a father welcoming back a prodigal son. I did not understand this for a long time. Then one day Muhammad took me aside and asked if being a Christian didn't mean being like Christ. Didn't Jesus forgive even his most ardent adversaries? So it was to be, and Muhammad consistently strove to emulate the Prophet Muhammad in all he did, knowing that perhaps Allah would forgive him one of his transgressions in return. While observing Muhammad, I have often thought that if everyone just had ten percent of his faith in God this world would be a much better place for all people of all colors and religions.

I owe a lot to Muhammad—my financial and spiritual well-being as well as a multitude of friendships that I have made over the years through his introductions. Ali has had many blessings. As his friend and confidant, so have I. I had the greatest of all blessings because my eye and my camera became the world's window to this magnificent life. If you like these photographs, you would have truly loved being there when the images they reflect were captured. Muhammad is both physically and intellectually stunning, and I hope these pages reflect a bit of that majesty and beauty. It is my sincere wish these photographs will help all those who may never know Ali to understand the miraculous movement of his life.

I would like to thank Muhammad Ali for all the things he has meant to me in my life. I love this man immensely. There will never be another one like him.